THE ART OF
HUMOROUS
ILLUSTRATION !!

THE ART OF HUMOROUS ILLUSTRATION

BY NICK MEGLIN

WATSON-GUPTILL PUBLICATIONS, NEW YORK

For Diane and Christopher, who know how to laugh.

Paperback Edition
First Printing, 1981

2 3 4 5 6 7 8 9/86 85 84 83 82

Copyright © 1973 by Watson-Guptill Publications
First published in 1973 in the United States and Canada by Watson-Guptill Publications,
a division of Billboard Publications, Inc.,
1515 Broadway, New York, N.Y. 10036

Library of Congress Cataloging in Publication Data
Meglin, Nick.
 The art of humorous illustration.
 1. American wit and humor. Pictorial.
2. Cartoonists—United States. I. Title
NC1426.M36 741.5'973 73-6676
ISBN 0-8230-0268-3
ISBN 0-8230-0269-1 pbk.

Manufactured in U.S.A.

Acknowledgments

As might be expected, any volume containing many drawings from many sources relies upon the generosity and cooperation of many people. To these people—as well as to any that may have been overlooked—my sincerest thanks:

Norman Blagman, London Records; John Boni; Len Brown; Peggy Buckwalter, *American Heritage*; Priscilla Colt, Harcourt Brace Jovanovich; Frank De Lizza; Lew Dorfsman, CBS; George Dougherty; Don Edwing; Ed Fenech; William Fletcher, *North Light Magazine*; Sara Ann Freed, Harper & Row; William Gardiner, *The Saturday Evening Post*; Tom Gatewood, N.Y. Football Giants; Woody Gelman, Nostalgia Press; Catherine Genovese, *Playboy Magazine*; Larry Gore; Fritz Henning, Famous Artists Schools; Peter Hirsch, DKG Advertising; Don Holden; Norb Hofman, *Newsweek*; Jud Hurd, *Cartoonist Profiles*; Oscar Hyman; Florence Keller, *Boating Magazine*; Nancy Kirkland, *Sports Illustrated*; Harvey Kurtzman; Hal Laurence, Combined Insurance Company of America; Ms. Levine, the Ben Roth Agency; Frank Mancini, RCA Records; Bill Negron; Ruth Rogin, *The New Yorker Magazine*; Ada Shearon, MacMillan Publishing Co.; Two Dames, Artists Rep Agency; David Wedeck, Focus Productions; Charlotte Zolotow, Harper & Row.

And a very special thanks to Len Brenner, Jerry De Fuccio, Al Feldstein, Bill Gaines, John Putnam, and the artists and writers of *Mad Magazine*.

Contents

Foreword

An Interview with Federico Fellini

Author's Note: In a book devoted to the humorous il-
lustration of twelve artists, it seemed redundant to
ask a thirteenth to write the foreword. For contrast, I
thought I'd ask someone whose creations stem—it
seems to me—from the same internal response but
whose expression manifests itself in other media.
The first name that came to mind was Federico Fel-
lini, whom I believe to be the most important visual
force in motion pictures today. A masterful photog-
rapher, like Cartier-Bresson, can move one to laugh,
to cry—but his work is *creative* rather than *created*,
capturing moments and images of life, not *construct-
ing* them. Fellini manipulates the eye, and of course
the mind, and we who follow his hypnotic lead do so
willingly, lovingly. Fellini's visual language has such
impact that it should come as no surprise to learn that
he spent a great deal of time in his formative years
drawing, and that during and after World War II he
earned a living doing caricatures of soldiers sta-
tioned in Rome.

Mr. Fellini preferred that this foreword be
presented as an interview between him and myself.
He has generously allowed the publisher to repro-
duce (for the first time) a few of his personal charac-
ter and costume sketches for the children in the film
on which he is currently working.

NM: Can you describe how your early drawing
years have helped your filmmaking?

FF: My activities in drawing and caricature were
simply the initial moment of a vocation which was
later to be more fully realized through cinematic ex-
pression. So, in this sense, it would be more exact to
say that it was this vocation which influenced and de-
termined my beginnings in the graphic field.

NM: Did you ever consider drawing as your ulti-
mate profession?

FF: No, I don't think so. At least, I don't remember
that I ever considered it as such.

NM: Do you use drawings as a point of departure
from which a scene or an idea can grow, or is your
drawing the final concept from which scenes are de-
fined and directed for the other specialists involved
(i.e., set designer, costume and make-up people, etc.)?

FF: In general, the drawings I make have only a
functional reason, and are closely linked with my
work as a director. Just as the screenplay represents
the literary, the verbal phase in the realization of a
film, it often happens that in the work of preparation
I make sketches, designs, figures, in an attempt to fix
and visually clarify a setting, a situation, a character,
the costume of a certain personage, a feeling. This
casual material, these "windbirds" (usually done on
scrap paper, backs of envelopes, etc.) serve as sign-
posts to orientate my collaborators: the scene de-
signer, costume artist, make-up man, etc. Unlike the
screenplay, however, this work of figurative clari-
fication is never developed systematically as some-
thing indispensable. And, indeed, I make many more
for some films than for others. It all depends on the
nature and needs of the film on which I am working.

On the other hand, I've never thought of making
drawings inspired by scenes I've already shot: to me
this would seem as pointless as a dressmaker going
on basting seams in a dress already perfectly fin-
ished. What I mean, you see, is that for me drawing,
designing, although coming from a very natural in-
stinct, never has an aesthetic finality. It is only an in-
strument, a means, a link in the chain by which fancy
and imagination are anchored in a cinematic result.
And even when I make doodles and drawings which
serve no apparent professional necessity—a carica-
ture of a friend seated opposite me in a restaurant,
the obsessive repetition of an anatomical detail while
waiting on the telephone, or attitudes, expressions or
indecipherable graphic allusions scrawled during
boring discussions—as I was saying, in these cases as
well it is a matter of an exercise, a professional habit
of immediately giving visual materialization to an
emotion, a snatch of some passing image, or some too
pressing fancy.

NM: Were your drawings for *Clowns*, for example,
from research, memory, or were these clowns of your
own creation?

FF: Sincerely, I shouldn't know how to answer.
Toward my own work I don't have a critical and
diagnostic attention which is so vigilant and con-
scious. I only know that when I am preparing a film
all that I do obeys only the necessity to define and ex-

press with ever greater precision the ideal film which I feel already exists objectively.

NM: In the "vision" scene of *La Dolce Vita* you actually played this serio-tragic sequence against a humorous undercurrent. Those trying to "cash in" on the "miracle" were shown in all their absurdity, while the people themselves—in their hungry desire to follow any sign of hope—destroy themselves and each other in the process. This is a "classical" approach to humor, I believe. How did you see it as the creator?

FF: You have asked a question and I am grateful that in a certain sense you have also provided the answer. I think that an author's views on his own work are just as disputible as anybody else's. In fact, the more a creative artist is indeed that, the less conscious he is of the creative phenomenon and of the expressive means, which to him is only a medium. That is why he usually betrays only the slightest degree of critical lucidity. Besides, when I am asked to confirm or elucidate on some aspect of my films I am at once alarmed by the suspicion that the film has partially failed—if it raises doubts and uncertainties of that type.

NM: While you seldom do a comic film *per se*, humor appears throughout most of your most important, albeit serious, films. Is this because you enjoy doing it personally, or is this because you feel it tempers the film's mood or helps its timing?

FF: In my way of thinking, there do not exist humorous themes or themes which are not humorous. Humor, just like the dramatic, the tragic, the visionary, is the collocation of reality in a particular climate. Humor is a type of view, of rapport, of feeling one has about things, and is, above all, a natural characteristic which one has or doesn't have. In this sense, to speak of utilizing the humorous to balance certain atmospheres or situations, tends to suggest, even though vaguely, an idea of premeditation, of calculated dosing, something which is absolutely extraneous to the whole phenomenon of humor, in fact the very negation of it.

NM: Are your humorous ideas based on actual situations, created, or both?

FF: I must beg you to pardon me, but I suffer from a singular form of color blindness which prevents me from ever clearly distinguishing the real situations

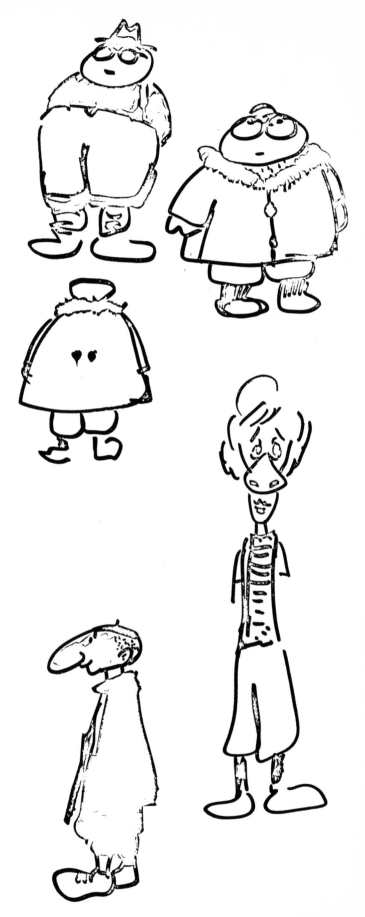

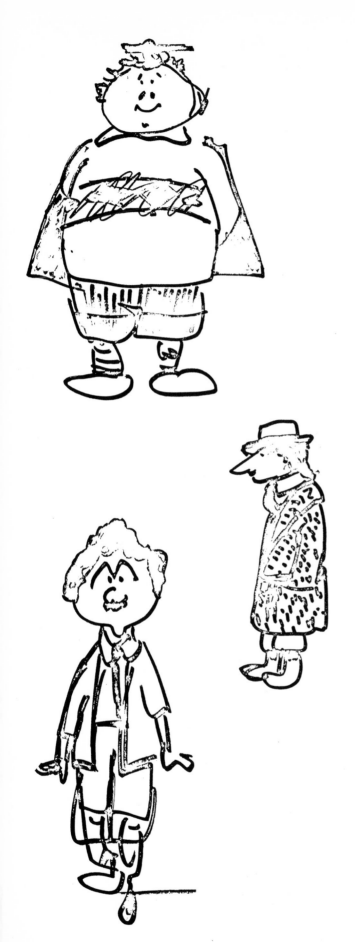

from the imaginary ones. As I just finished saying, I can only repeat that, for me, the humorous is a feeling one has about reality, and the imagination participates in this feeling as an activating and energizing element.

NM: Do your humorous sequences offer you as much satisfaction as your serious ones? Which is more difficult to achieve?

FF: Frankly I don't recognize in my films an attitude which could be surgically subdivided into serious and humorous sequences. The humor, the climate of a film, is essentially a homogenous factor; here and there one can make out major or minor condensations or rarefactions of this climate, but even this variability is the fruit of an equilibrium, of a rhythm which takes in the whole film. To isolate moments, fragments, seems to me an unnatural operation, as it would certainly be unnatural in my case to isolate one film from another. As a consequence I, too, have an all-embracing rapport with a film, and to break it up into diverse and momentary expressions would inevitably mean altering it, changing its nature. Obviously, these are very personal reserves and objections, but perhaps from a critical point of view not only legitimate but useful for clarification.

NM: Has humor from films, art, books, television, or periodicals influenced you in your films, and, if so, can you say which had the greatest impact?

FF: I think it would be more stimulating and interesting if it were you who answered this question, tracing in my work the echoes, the influences, the sediments you presume to find in it.

As for me, I share the opinion that all we are and all we do is no more than a system of interdependent rapports between us and the world outside us, a complex of reciprocal and continuous derivations, projections, and reactions. Limiting oneself to cataloging those which are the precise matrixes, the determining sources, the exact origins which contributed to the formation of our individual universe, would mean referring to an extremely complex and absolutely creative process of assimilation and transformation in the most superficial terms and giving only the roughest outline to such a process.

And, besides . . . why always speak of influences, and never of coincidences?

Rome, June 1973
(Translated by Eugene Walter)

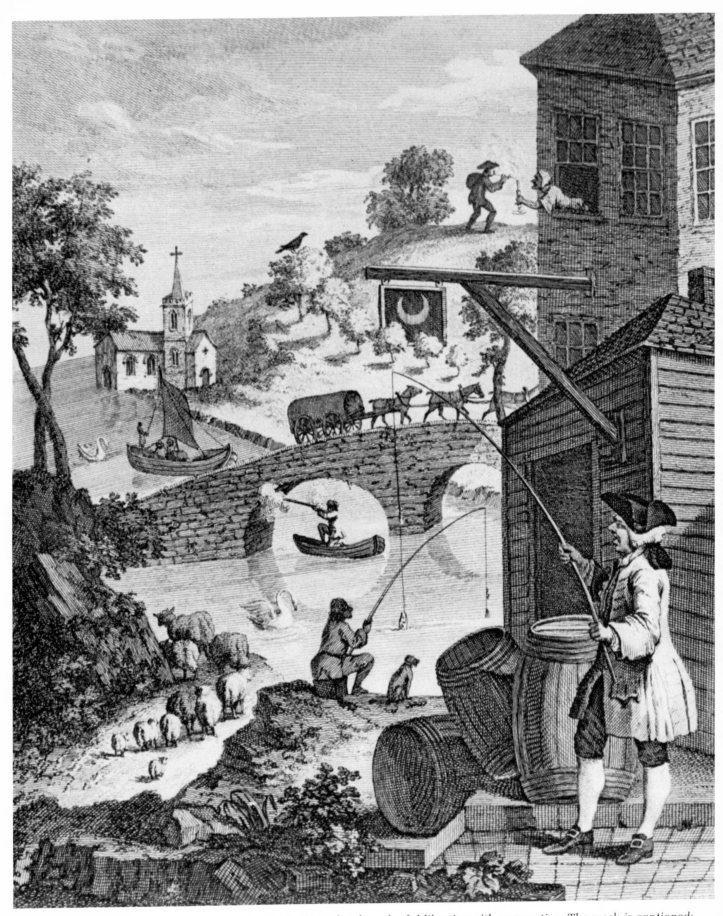

William Hogarth. *An early engraving in which Hogarth takes playful liberties with perspective. The work is captioned: "Whoever makes a DESIGN without the knowledge of PERSPECTIVE will be liable to such absurdities as are shown in this FRONTISPIECE."*

Introduction

A humorous illustration is, or should be, more than a piece of work that carries a humorous message or point. The *attitude* of humor should be apparent or it is devoid of the purpose for which it has been created. At a glance one should know that the lighter side of his emotional spectrum is about to be tapped.

With this in mind, the purpose of this book is not to provide a portfolio of samples to serve as a convenient reference of successful styles and approaches for students or other artists to imitate—nothing can help the would-be imitators. Anyone bent on imitation obviously doesn't comprehend the very basic fact that humor is either there or it isn't! It's a highly personal quality that can't be bought, learned, or come by through some magical osmosis provided by imitation. It *can* be *developed*, however—not through imitation, but through careful analysis of successful work.

Humor is of its own time and age, reflecting life in its own environment and current situation. If it holds up through the years, so much the better. But pleasing posterity, it should be remembered, is not its purpose. Its purpose is immediacy. Much can be learned from those humorist/artists of the past who sought to

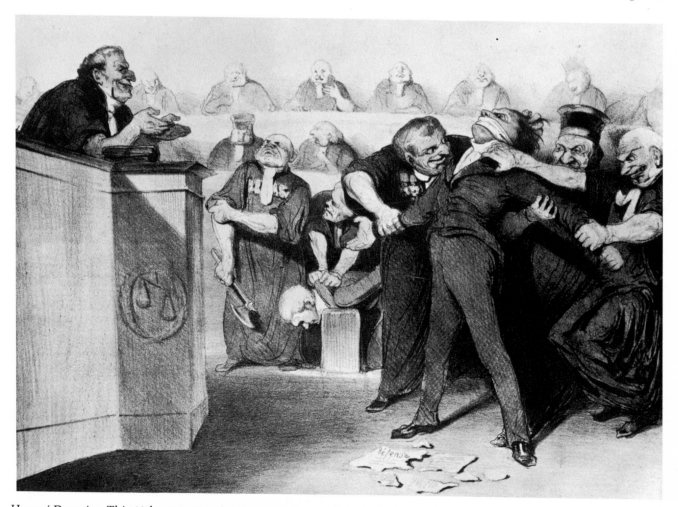

Honoré Daumier. *This 19th century artist at one time spent six months in prison for his satirical attacks on the courts and lawyers of France. This lithograph is entitled: "The Accused Can Now Have His Say."*

Aubrey Beardsley. *A master of decorative graphics, Beardsley caricatured many of his contemporaries for both personal enjoyment and publication. Here he portrays the dapper James McNeill Whistler.*

AUBREY BEARDSLEY.

capture the absurdity of the human condition: Hogarth, Daumier, Goya, Toulouse-Lautrec, Ghazzi, Bosch, etc. These artists all spoke through a need, an inner voice that directed their feelings and thoughts into a humorous result. Aubrey Beardsley's illustrations and designs are very largely satirical, as is—more recently—much of the work of Jean Cocteau, George Grosz, Jack Levine, and William Gropper.

A contemporary painter, Allen M. Hart, devotes a great percentage of his "serious work" to a humorous end. In his *Dairy of Jipson Pitt*, Hart observes: "To caricature life well ... [the artist] must be a caricature himself. Through his own eyes he can perceive elements of his own existence that tend to make him appear ridiculous in the eyes of others ... but because others see him as such [ridiculous], he is free to parody their existence, feeling justified in a sense of alienation. In fact, this is an important motivating force in ... becoming an artist in the first place."

Humor is, after all, but one small part of the world of ideas, and ideas are not a commodity that can be dealt with by ordinary standards. The creative process has never been entirely understood by analysis, by experts on the subject, or by those involved in the process itself—which perhaps explains why so many problems exist between the executive levels of management, supervisors, technicians, etc., and the people who create for them. The term "temperamental artist" has been used as a broad dismissal of these impossible people who can't deal with things on a logical level. The simple truth is that some individuals can turn on the creative juices almost at will, responding to the challenge, assignment, or deadline in a "professional" (reasonable!) manner, while others sweat and squirm all day to no avail, only to have the perfect solution occur to them after they've given up for the night and gone to bed from sheer exhaustion, at which point they leap up and begin to work as if they were starting a new day rather than ending the old.

There's no accounting for these opposite types. If choice were involved—and it's not—the former type appears more practical. And yet many of those who perform best under pressure lament their dependence upon it and are frustrated by their inability to create for themselves or originate self-imposed (and perhaps more rewarding) challenges. We've all met the commercial artist who promises himself he'll go out landscape painting—and never does—or the advertising copywriter who's going to reveal all in a stage drama—and never does. Not that these particular professions have a monopoly on these types, it's simply the "we are what we *do* and not what we *say*" philosophy working overtime. The novel that's forever being written is not a novel until it *is*, and its would-be author lives in a fantasy world that no one else can share with him. Unfortunately we're not judged by our potential, only our production.

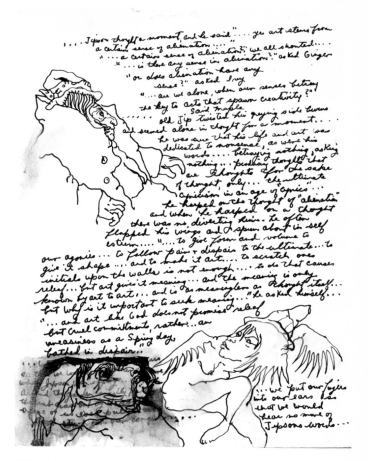

Allen M. Hart. *A typical written/drawn page from Hart's journal*, The Diary of Jipson Pitt. *Hart uses direct pen and India ink line, often adding acrylics as a second stage to these internal flights of fantasy.*

The twelve artists represented here *have* produced. Each is at the very top of an area in which he chose to specialize, while at the same time being a versatile and well-rounded artist. Unfortunately this book cannot show the many facets of each artist's work; we've had to narrow our point of view to humorous illustration only, which—while representing a peak of excellence—obviously doesn't begin to cover the full range of their talents.

SPQR

LILIO REGINA

Aragones

Sergio Aragones

Pantomime on Paper

"I have circled the globe, and though I speak Esperanto and several languages with varied degrees of fluency, I have never failed to communicate anywhere in my favorite language—*pictures*. The spoken word is always subject to interpretation, but the drawing literally speaks for itself." So says Sergio Aragones. "For me, pictures were a way of thought before they became a way of life. I was able to comprehend anything that could be visualized. Though I read a lot as a youth, it was the pictures that initially attracted me to the book." Aragones' response to visual stimuli is to be expected—it is not only the mind of a child that seeks immediate comprehension. The picture is the ultimate in communication because it can work on many levels of understanding simultaneously. It breaks things down to the barest of essentials: its simplicity educates; its complexity entertains. We can understand the illustrated book without reading a word.

Although his pantomime gags have appeared all over the world, Aragones is perhaps best known for "Marginal Thinking," a regular feature in *Mad Magazine* devoted to Aragones' sight gags since it first appeared in January, 1963. More than decorations inserted on page borders or fillers between illustrations of other artists, the "marginals" have a strong following among pantomime gag aficionados. Having created anywhere from 15 to 25 per issue (eight issues per year) Aragones has done close to two thousand. (Paperback Library has published a collection under the title *Marginally Mad*).

The cartoon mural

Aragones is truly happiest when working. His prolificacy is proof indeed of his love of creating the visual gag. He is the compulsive artist: drawing on napkins and table tops; declaring war on every blank area left on some magazine or newspaper page by a well-meaning art director or page layout man. Many of these spontaneous outbursts of humorous energy are left discarded; just as many find their way to friend's apartments or restaurant waiters who pick up after him. Some eventually see print if Aragones feels the gag worthy of inclusion in one of his professional assignments or his beloved "marginals."

If Aragones is happy with one gag, he's twice as happy with two gags in one drawing, thrice as happy doing three, and so on up the scale until the "cartoon mural" stage is reached. This penchant for filling the reader's eye with more gags than it can possibly absorb at once has become an Aragones specialty. The drawing stops and starts as the artist's sense of design dictates, beginning at a random point and growing over the page from gag to gag. The gags are neither pre-planned or pre-sketched, but created as he goes along and drawn directly.

Early influences

Aragones' murals, as well as his talent for creating pantomime gags, can be traced to early influences and his experiences as a youth.

"I was born in the little town of Castellon, Spain, in 1937, but on account of the Spanish Civil War, my family had to leave the country. I was about six months old at the time. We stayed at a refugee camp in France for a few years, where I started to pick up French. Later on, we moved to Mexico City where I spent most of my youth. My father's brother had a great sense of humor. He encouraged my early attempts at drawing funny pictures by keeping me well stocked with art supplies and cartoon magazines. Some of the Spanish newspapers, such as *La Codorniz*, carried many of the American daily comics, like *Blondie* and the *Katzenjammer Kids*, translated into Spanish.

"Throughout school my cartoons always brought great annoyance to my teachers and great delight to my friends. In high school, a classmate urged me to submit my work to the professional market. I didn't, but she did without my knowing it. Some weeks later, she showed me a copy of a little magazine called *Ja Ja*. I stared in disbelief at *my* cartoons, right there in print. I got about a dollar a cartoon, but the thrill of it was much more important than the money. From that time on I submitted cartoons regularly to Mexican magazines, selling a large percentage of them.

"My parents weren't too thrilled about my career in cartooning: in Mexico, even more so than in the States, a title or a degree is very important. So, I went to architecture school after high school to please my

15

parents and help them realize their dream: a professional title framed on the wall. The first three years were interesting with history of art and architecture and related courses, but after the third year the curriculum became quite technical and I became disinterested. Professionally, I was doing a page of six pantomime gags weekly for a magazine called *Mañana*. To lift my spirits, I did a daily mural cartoon depicting school events. Even then, most of the humor was sight gags. Done with a big Magic Marker, it was displayed daily in the school corridor. The other students were so disappointed when I missed a day that I had to learn to work fast in order to meet the demand—even on exam days!"

Working with fountain pens

Aragones finds fountain pens indispensable when working on one of his cartoon murals. Experience has taught him that inexpensive fountain pens serve his purposes as well as the more expensive varieties of cartridge or fillable pens, provided he rinses them out regularly with warm water. It's the point that most concerns him, and many companies, such as Esterbrook, furnish a complete line of replaceable nibs at reasonable prices. Aragones fills them with F-W India, a rich black ink with a formula that reduces pen clogging to a minimum. The fountain pen allows him the freedom to produce while thinking, as his drawing evolves, Aragones can work on, unconcerned about dipping, spilling, or broken nibs to change.

Because of the nature of his drawing, Aragones prefers to work when and where the muse strikes. His portable studio of filled fountain pen and any available drawing surface has proven very beneficial to his career. Aragones has actually sold ideas and drawings executed on menus, napkins, and matchbook covers. He has used just about every type of pen available, from Rapidograph through Pelikan (the latter line containing the Graphos pen with interchangeable nibs; the Technos, a cartridge-filled pen with a point action similar to the Rapidograph; and the new Pelikan 120, a fountain pen capable of utilizing India ink. His favorite *this week* is the inexpensive Esterbrook fountain pen equipped with their #2556 point.

Quality of line

"Although hand pressure on any flexible point will create wider or narrower strokes, I prefer to let the point ride the surface of the paper, forming a basically single-width line," says Aragones. "A constant line seems less distracting (I supply so many other distractions, I don't need more). A thick and thin variable-width line is too interesting. This causes the reader's eye to travel around rather than concentrate on the total theme or idea. I want the eye to travel from gag to gag when that stage is reached, not from line to line. For that reason, I also try not to have each line appear labored over. A general can be wearing 400 medals, but each one is drawn directly and freely. Each may have a different gag on it, but the *total* concept, the 400 medals, is more important. None should stand out or it will take away from the basic idea.

"I often draw right through, rather than make lines begin and end precisely. This helps create the feeling of spontaneity that I feel is the most important element in my work. I use reference in the same way, allowing my mind to step into the photograph and have a look around—so that my drawing will look as if it had been done on-the-spot, and not copied out of *National Geographic*—although it really was!"

Black and white as color

Aragones has no preference for drawing papers or boards, being more concerned with how large he can get them than weight and surface texture. His color work is minimal, usually out of necessity. "I'm terrified of color," Aragones admits. "I think in black and white. I know lines and outlines. You can't color a line drawing and expect the same kind of result as a drawing where the color was carefully thought out beforehand. Filling in outlined areas *à la* coloring books produces a drawing with color, not a color drawing. I do it only when necessary and, naturally, do the best job I can. At these times, I use colored Magic Markers, applying the tints directly into the areas. I use them as they come, seldom mixing.

"I work quickly to keep the coloring as spontaneous as the line work in an attempt to marry both stages of the drawing; my loose pen work would look hideous with carefully rendered color. I use watercolor and dyes from time to time, but no matter how it's finished, I'm usually not as happy with the completed work as with the black and white stage." Aragones is clearly more comfortable when thinking in terms, as he puts it, "of black and white color," meaning the gray tints he attains with shading sheets, India ink wash, or gray Magic Markers.

The art of pantomime

While successful humor works on several levels, much of it is based on contradictory or paradoxical situations. Comedy and tragedy appear miles apart on the emotional spectrum, but like the dramatis personae, the symbolic masks of the drama, they are very closely related. We laugh at slipping on a banana peel (someone *else* slipping, not us!) and the custard pie in the face. The seltzer bottle reduces the pompous ass to everyman's level with just one well-aimed spritz; just about any humiliation that boss,

bully, landlord, or mother-in-law suffers guarantees a guffaw.

"In these cases," observes Aragones, "the artist is the circus clown and the reader is his audience. The clown can make you laugh because he can make you cry. Sometimes you laugh *with* him, other times *at* him, but you always cry *for* him if he succeeds in becoming an extension of his audience. I learned this while studying pantomime with Alexandro Jodorowsky. [Marcel Marceau, the gifted French pantomimist, came to Mexico City for a lecture series and later opened a school there. Aragones, already graduated, was working as an architect's assistant during the day while attending the workshops several nights a week. He became so adept at mime that he worked as a clown on weekends as well as a stunt diver and underwater performer.]

"Audience involvement is especially apparent when you know it is not a clever line or play on words that they are relating to, but a gesture or an expression in the context of the situation that is eliciting laughter. I try to capture the same elements in my cartoon work, which is, for the most part, pantomime on paper. I act out the scene in my mind as I'm committing it to the drawing surface. My wife Lilio and friends who've watched me work say they can practically read the script from my face—I wear each expression I'm drawing."

Laughing at one's self

Sometimes there's guilt associated with laughter derived from actual situations (often at the expense of others). But framed in a humorous creation, be it a gag cartoon, illustration, or animated film, we can laugh at this same kind of situation more freely. When the mouse slams the door on the cat and he becomes a flat, two-dimensional image, it's harmless fun: we are released from guilt.

Another sprout from the same "expense of others" branch is finding fun in that which others take seriously. Ridicule is, of course, the extreme example of a completely negative approach, alienating more than endearing. But gags created out of an impish approach (one that momentarily sets up a new perspective between the reader and his interest) are usually well received: they point out intensity rather than absurdity. Most people have the facility to be amused when asked to look at themselves, provided there's genuine humor at the core.

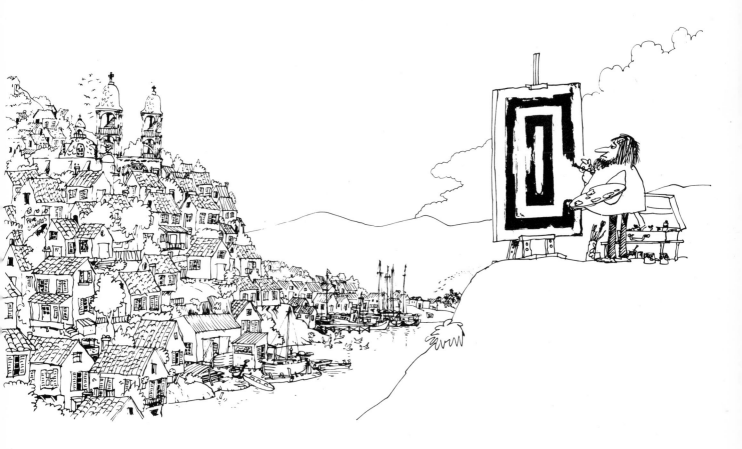

In this fountain pen study, Aragones satirizes the artist who seeks out the picturesque for his painting inspiration.

"At times like these," Aragones adds, "you must realize that your own disinterest or indifference is not shared by all. It's always easier to laugh at a joke about the other fellow's candidate than about yours. However, learning more about the other point of view can be very helpful. When you broaden your knowledge of a subject, you also broaden your scope for humor: you see more opportunities for fun, as well as develop a sense of what is liable to offend rather than entertain. That's why I base so many of my gags on my own experiences, whether as participant or observer.

"When I did a pantomime gag treatment on football, for instance, my prior knowledge of the sport was limited. I had only a surface knowledge, and nothing bothers me more than gags based on obvious or cliché situations. I could read up on the subject, but then I would be influenced by the sort of research usually available on most sports: rules, records, and technicalities—deadly! Statistics are always an important part for real fans, but their gag potential is very limited, and in reality have little to do with what makes this sport so popular. Football is action, sudden change, movement. It has great appeal because it represents our era and offers release for pent-up emotions. And the football fan takes it all very seriously.

"I watched a few games on TV, looked through football magazines, and talked with friends who were avid fans of the sport. While this all proved very helpful, it wasn't until I actually attended a game that I found the key element. The total football picture must include the fans: the *reaction* to the game is as important as the game itself.

"I was able to observe first hand that which alternately pleased and frustrated the spectators. Here were the insights I needed to pick out those particular actions or moments that both a football aficionado and just a casual spectator could relate to and find humor in. I was also able to scan photos and reference material with a more educated eye, having a keener sense of what that pile of enmeshed bodies actually represented."

Humorous impression of life

"Most of my work deals with a humorous impression of life rather than accurate representation. For instance, when I do a sequence that needs a locomotive, I go to the library or bookstore and skim books on the subject until I see a picture of what I think a locomotive should look like. I study the elements that say 'locomotive' to me, then I put the book back on the shelf, go home, and draw that locomotive.

"I don't want the research near me for fear of being overly accurate. My impression is more imporatant than an ability to copy. While my locomotive is really an invention and could never actually function, there will be something to suggest the real thing—just enough for the kind of recognition I'm striving for, but not enough to get in the way."

Sergio Aragones works simply and with minimal use of art basics, despite his background and expertise. He never loses sight of the fact that he is a humorist, an attitude that, perhaps more than any other single factor, is responsible for his great success.

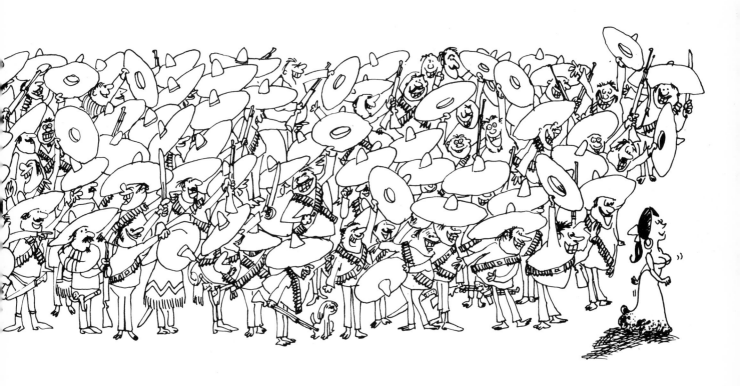

Aragones delights in creating scenes that flow in one direction while the gag idea moves in the opposite direction.

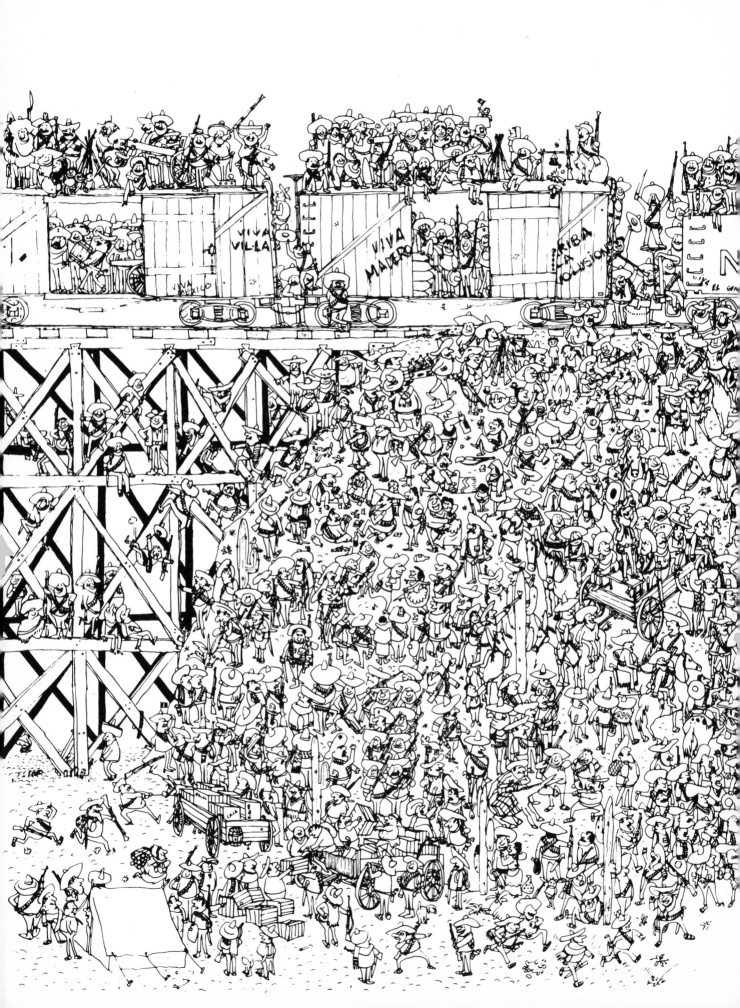

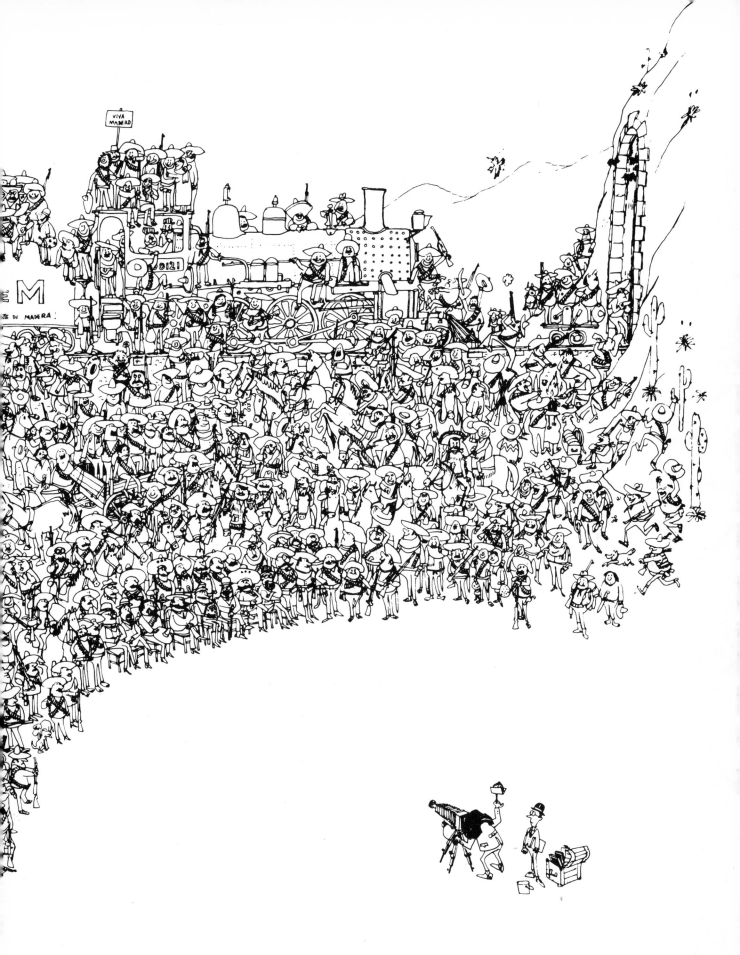

"Say Cheese" is a typical Aragones cartoon mural. The original
measures over twice the size it appears here.

"Peace" is one of a series of ten decorative cartoon plates the artist designed for his wife. Another of this series opens the chapter (page 14). Courtesy Lilio Aragones.

"A Bird In Hand" was executed in India ink, with watercolor used only on the birds. Courtesy of the artist.

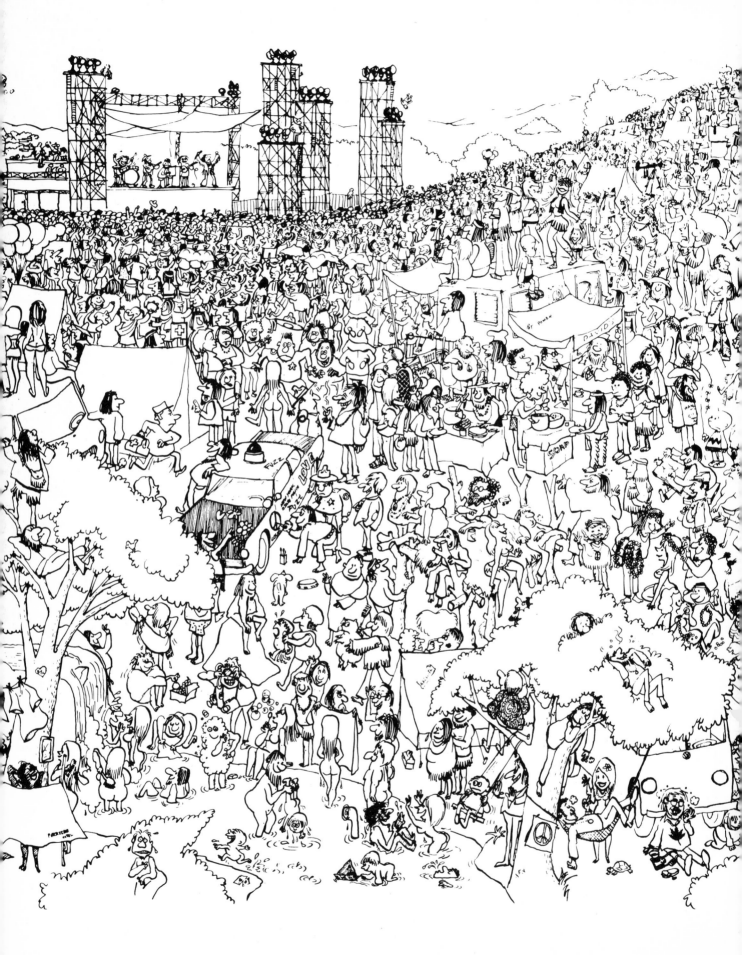

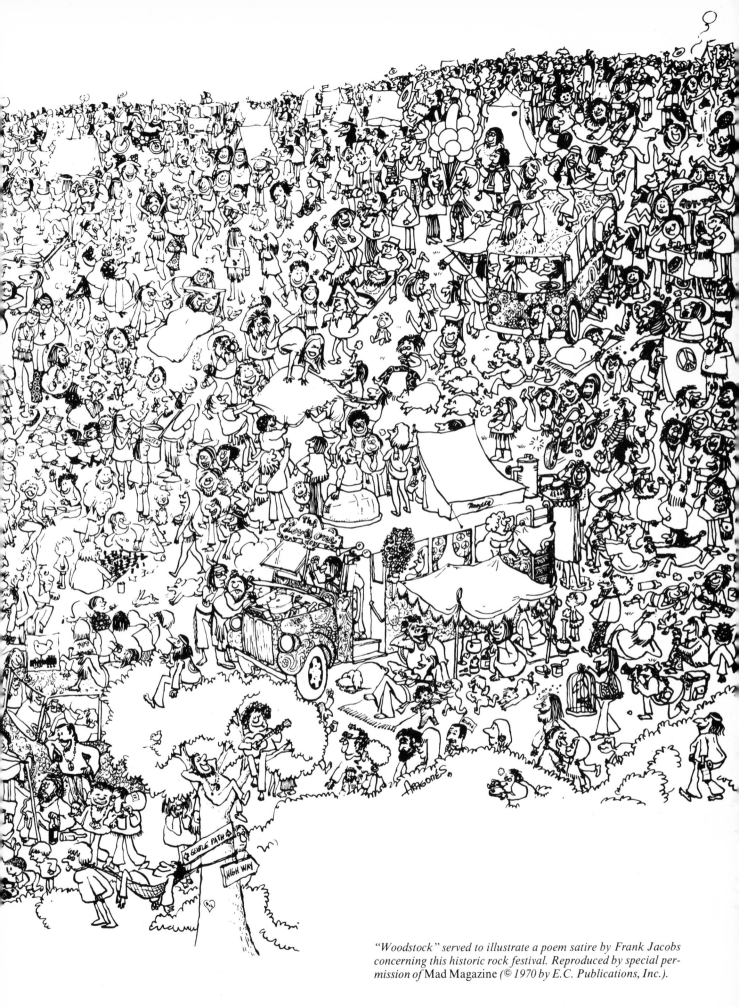

"Woodstock" served to illustrate a poem satire by Frank Jacobs concerning this historic rock festival. Reproduced by special permission of Mad Magazine *(© 1970 by E.C. Publications, Inc.).*

GREECE

GEORGIA

NEVADA

ALASKA

Paul Coker

The Decorative Approach

"Art in most illustration assignments is only decorative," says Paul Coker. "It's seldom an essential part of the text; unlike the text, it cannot stand alone. The artist's function is to bring attention to the text, the page, the spread, the story, the cover, or whatever. He must attract the eye, supplying an interest or appeal to the story beyond the draw of the title. For me, the decorative approach is the way to accomplish this."

The humorous illustrator, in these cases, faces a harder task than when the drawing is essential to the work. In a comic strip or gag cartoon, for example, there's a working interdependence between the writing and the drawing. The reader here must observe *both* to derive any satisfaction, whereas the text reader can ignore the illustration completely without loss of enjoyment or comprehension. Consequently, the artist in the latter situation is employed for esthetic reasons: "to attract the eye." The illustrator must, in a sense, add importance to the article, striking up interest or curiosity. As for the humorous illustrator, he must also set the mood—"warm up" the audience as they do before a television comedy show—until the text can carry its own weight.

Illustrating the text

The problem of what to draw or which point in the text to illustrate (unless specifically outlined for you by an editor or art director) is more than an intriguing challenge: careers (certainly reputations) are born and buried with the solutions.

"I try to take the most extreme element I can think of within the context and framework of the author's intent," relates Coker. "For example, when assigned an article by *Stereo Review Magazine* concerning the testing of loudspeakers, I was called in, obviously, to add a light touch to the text and not to execute photograpic-like renderings. Since the subject of speaker volume was stressed in the copy, I tried to come up with a visual exaggeration of this point. The outcome was a fellow with a clipboard measuring audio decibles between two blaring speakers: The humor (I hope) was in his complete absorption of the sound force, oblivious to the fact that the walls have blown down around him and that his shoes and some of his clothes have been blasted away as well.

"I find my greatest drawing pleasure in exaggeration. The more I exaggerate, the happier I am with the work. There's a *commercial* limit which I understand, however, since you can only go so far before you're beyond the toleration of the general reader. A humorous illustrator should not only work for his own amusement, but should also work to enhance someone else's ideas."

Another difficult problem to overcome is space. While the complaint of not being given enough room to work in is standard, Coker notes that the opposite can be even more detrimental: "Much humorous illustration suffers when the idea isn't significant enough for the space devoted to it. A full page for a small idea is a mismatch, and no matter how much filigree and footwork the artist adds to the drawing, the odds are against his producing a successful piece of work."

This situation can occur when an editor is not too confident in the strength of the text. The artist is called in to "save" it with illustration, an attitude that's inherently counter-productive. The situation is then compounded by designing a layout that affords the artist large areas—the kind the artist always dreams of getting, and never does, when on an assignment he can really do something with. In these "you gotta bail me out of this jam with great illustration" attempts, the ideas generally don't warrant the apportioned space and subsequent attention. The text (which should have been buried in the back or sandwiched between two stronger pieces) suddenly gets star treatment, calling undue notice to the situation. The artist can fill the space as best he can; he certainly cannot *improve* the text by his efforts.

Greetings: Uncle Sam style

Coker was born and raised in Lawrence, Kansas. He liked to draw and was encouraged to do so by his parents and teachers. As a child, he never dreamed or fantasized about a career as an artist—it never occurred to him that he would be anything else.

Coker received no formal art training until he attended the University of Kansas as a drawing and painting major. He chose this course of study over the more commercial subjects offered at the univer-

A Coker studio card rough, drawn with pen and colored markers.

sity and at professional art schools, because he believed a firm grounding in the fundamentals would provide a broader and more useful foundation for a career in cartooning. Specialization, he feels, should come after basic levels of skill have been attained.

After graduation, Coker became involved in some free-lance art assignments, mostly advertising spots. As a naval reserve member, he missed more meetings than the navy believed tolerable—even for an artist! Two years of active duty brought outside activities to a halt. Some training visual aids work helped pass the time until his military stint was over.

As a civilian, Coker returned to Kansas City, where he found work at a radio studio. The station, just granted a television license, needed a versatile artist to design station identification cards, announcement spots, do lettering, ad promotions, and fill other graphics needs that might arise. Coker learned many techniques here, from the use of color corrected grays (a system designed to balance gray tones and color by the way they televise rather than how they appear to the eye) to the use of photos and collage for subjects where his lighter approach might be inappropriate.

After a year or so of multi-faceted television work, Coker had his own idea for a program. Believing it salable, he brought it to New York City for presentation. However, Coker was very reluctant to show his idea around, a reaction to the many stories he'd heard about naïve Midwesterners returning home duped, their ideas stolen.

"What isn't shown, isn't sold," Coker laments, "but it isn't stolen either." It wasn't a wasted trip, however. He got something very positive from it: a new goal—to be part of the excitement of New York, heart of the publishing world. Coker returned home and began working toward that end.

Greetings: Hallmark-style

Coker soon found work free-lancing for Hallmark Cards, whose home base was Kansas City. At that time, the humorous line of greeting card manufacturers consisted chiefly of cute animal situations. At first, Coker created whimsical situations and did roughs for proposed cards. Later, Hallmark asked him to work fulltime, helping develop a "studio card" line. This special type of greeting card became an enormous success.

The Hallmark line was one of the forerunners of the "neuter school" of studio cards, featuring an enigmatic character that was neither male nor female. This humanoid blob was designed to replace the cutely-drawn animals originally used to carry much of the studio card line's humorous messages. The reason for the neuter was strictly business: any card featuring a particular sex was limiting the card's salability by at least half. A woman, for example,

could send a neuter birthday greeting to a man or another woman without concern, and, of course a man could do likewise with the same card. Card segregation is an important consideration in this field where card display means the difference between sale or no sale. There is no advertising or promotion work involved with this product; it's entirely a point of sale commodity. For this reason, display and counter space is limited and highly competitive. Thus, a card with a more universal appeal—suitable for either sex—is at a premium.

Coker worked primarily with Phil Hahn, a writer, whose verbal approach to humor was very compatible with Coker's visual approach.

After two years of working fulltime at Hallmark, Coker felt that he might be ready for another trip to New York. Hallmark was understanding and signed him to an exclusive free-lance arrangement which would at least help Coker along while he tried to establish himself in commercial art. Coker's successes at Hallmark, however, proved of little value when showing samples to prospective clients; he was immediately typecast as a greeting card artist and nothing else. To remedy this, Coker designed a new portfolio with entirely different samples: spot drawings, humorous illustrations, book and jacket designs, etc. On the strength of these, he was able to secure assignments in advertising, books, and magazines. Sales to *Esquire, McCall's, Look, Good Housekeeping, The New York Times Sunday Magazine,* and *Playboy* were encouraging, albeit sporadic.

Hahn, in the meantime, had also ventured east to expand his own career as a writer. He was soon doing free-lance articles for *Mad Magazine*. Hahn introduced his artist friend to *Mad's* editors and Coker thus began a relationship he still enjoys today. The friends collaborated on several pieces for *Mad, Playboy,* and humor books before Hahn eventually moved on to television, where he achieved much success, including an Emmy as one of the original writers of the popular "Laugh-In" series of the late 60's.

Coker also began to employ his drawing talent in areas of specific interest to him: a sports-car buff, he became a regular artist in *Car and Driver;* and his political cartoons appeared three times a week in the now-defunct *New York Daily Mirror.*

From start to finish

Coker invariably prefers his pencil originals to what finally gets printed. "I'm always disappointed with the finishes," he claims, "because I guess I'm always comparing the end product with the loose, spon-

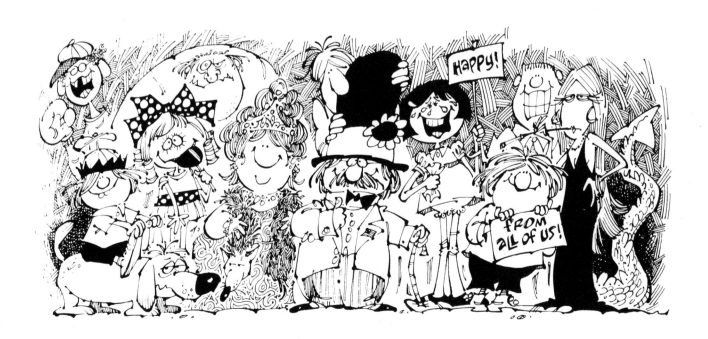

A studio card finish, in this case executed in pen and ink wash.

29

taneous sketches. I usually work out the roughs on thin typewriter paper; from that point on the work goes downhill." Coker generally redraws the rough sketch entirely, using a Strathmore 3-ply, medium-finish paper for the bulk of his finished work.

The inking stage is executed with a Gillott 659 crowquill point: a flexible, durable nib that responds to the various degrees of hand pressure applied in the course of the work. Coker finds Higgins India ink thin enough to keep the point flow steady, although the black is not as dense as he prefers when brushing in large flat areas. For this latter stage he'll use a #6 or #8 Winsor & Newton Series 7 red sable watercolor brush and either Higgins India ink or Artone Extra-Dense Black.

The pen line

"I used to use brush for line very early in my career," recalls Coker, "but I found my work had the Disney look—you know, two tapered lines with filling in the middle. This was to be expected, I guess, insofar as I was influenced by the Disney style. But I later balanced it out by switching to pen when I became more influenced by Ronald Searle's drawings. I'll probably switch to wet plaster when my 'Michelangelo period' finally comes."

A careful study of Coker's pen line reveals that he doesn't follow the contour to suggest form or to outline perimeters in the usual manner. The line itself "ends in a bump," a loosely controlled hesitancy that seems to stop and go by its own whim, a push-pull kind of effect. "It's a technique that I developed and, unfortunately, rely upon too often," admits Coker. "I say 'unfortunately' because you become more influenced by the technique of the drawing rather than the *idea*. When this happens you limit your creativity and your growth."

"Most of my color work is executed with markers," continues Coker. "I work almost exclusively in a tight technique for the basic structure and find the loose, spontaneous effects I get with markers an ideal color complement to my line work. I use a full range of grays, whether India ink wash, gray markers, lampblack, or shading sheets when tone is permissable.

The time for decorative work

"I use less filigree and decoration when I'm working on a satirical drawing than on a whimsical piece," states Coker. "Satire makes a direct point and you don't want to confuse or misdirect that point by overworking or adding too much extraneous material.

NAVIGATOR

COMBAT

DOGMA

BOONDOGGLE

RAMROD

DUNAMITE

"The decorative artist is free to entertain visually, enhance the idea, and perhaps even improve it. Since the concept is not intended to be earth shattering, attention should be paid to the *mood* of the idea rather than its impact."

Ideas are what humorous illustration is all about, and an artist must always bear in mind his responsibility to communicate them. The decorative approach must remain a secondary consideration until the idea has been established and presented in a manner that meets with the artist's personal satisfaction as well as that of editors and art directors who are presumably an extension of their ultimate readership.

Now, the artist is free to enhance the drawing with whatever he feels necessary to his personal approach. He must maintain objectivity to prevent overworking or any other distraction from his original consideration: the idea itself.

The rough vs. the finish

"There's no formula, rule, or pattern to follow in the idea stages of a drawing," suggests Coker. "Sometimes a complete situation pops into your mind; sometimes just fragments (isolated thoughts that can be brought together and developed into a whole), and sometimes—nothing. I've found that thinking on paper is the best way to get things going. Even a *bad* solution is helpful—you've at least learned what you *don't* want!"

Coker works out his ideas by doodling, incorporating the best of each of his countless thumbnail sketches into a final rough which he redraws directly onto the finished stock. His pencil line here is almost as loose in the final version as it is in the previous work. Only when an editor asks to see the pencil work prior to finishes does he work them up further, preferring to allow his pen a freer and less deliberate flow.

While "happy" accidents and spontaneous changes add immeasurably to the drawing, Coker often prefers the free, suggestive qualities of his pencil drawings to his finished ink work. This agony is familiar to many artists: the loose/tight, potential/final, rough/finished battle where what might have been always seems better than what is finally realized. But this is a very private struggle fought within the artist's mind. As viewers of the finished work, we're far removed from this personal conflict. We judge only what we see. And what we see, when produced by as imaginative an artist as Paul Coker, can only delight—the very function and purpose of the successful humorous illustrator.

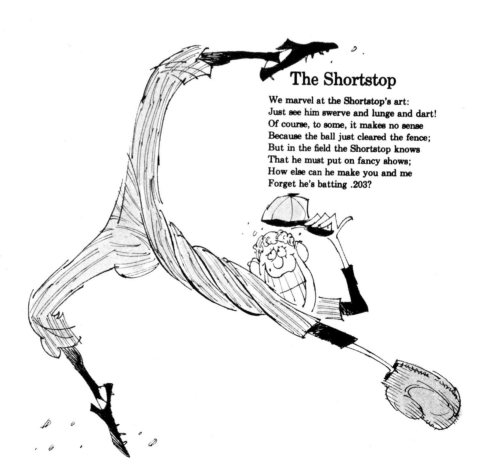

The Shortstop

We marvel at the Shortstop's art:
Just see him swerve and lunge and dart!
Of course, to some, it makes no sense
Because the ball just cleared the fence;
But in the field the Shortstop knows
That he must put on fancy shows;
How else can he make you and me
Forget he's batting .203?

(Left) Roughs for a Hahn/Coker spread for Mad Magazine, *drawn with pen and gray markers.*

(Right) This illustration appears in the chapter dealing with baseball in the Jacobs/Coker paperback, Mad For Better or Verse *(published originally by New American Library). Courtesy Frank Jacobs.*

JUNIOR EXECUTIVE OFF ON A TANGENT

LADY IN A SNIT

LEFT IN A HUFF

PEDESTRIAN ADMIRING A PASSING FANCY

MECHANIC LABORING UNDER A DELUSION

WOMAN DRIVING A HARD BARGAIN

This Hahn/Coker spread was drawn in pen, ink, and Luma liquid watercolors. Reproduced by special permission of Playboy *Magazine (© 1962 by* Playboy).

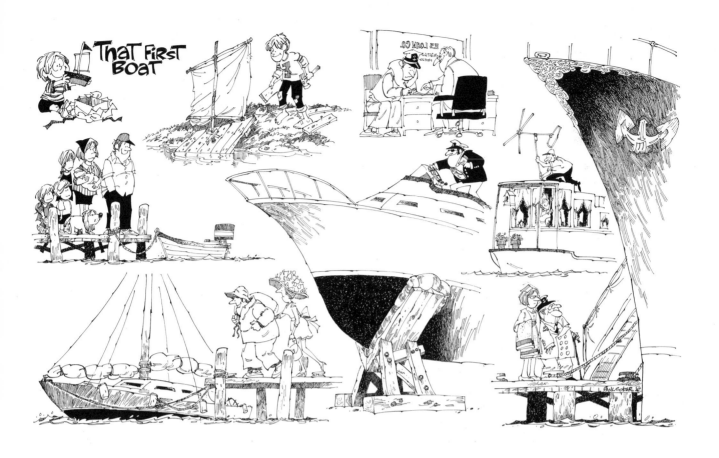

A pen, ink, and wash spread dealing with the evolution of a boat-owner from first taste to final floating mansion. Courtesy Boating Magazine.

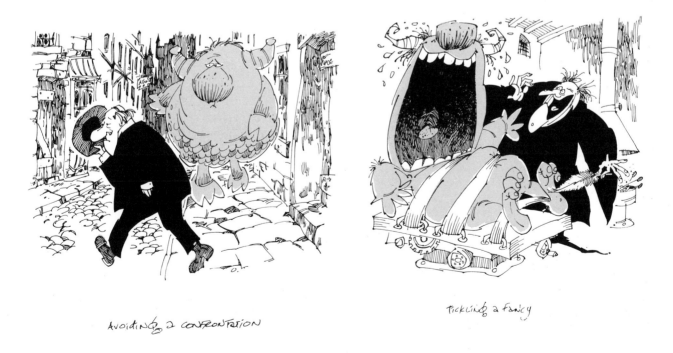

Typical examples from Horrifying Clichés, *a popular running feature in* Mad *that creates a monster situation to fit the expression. Reproduced by special permission of* Mad Magazine *(© 1971 by E.C. Publications, Inc.).*

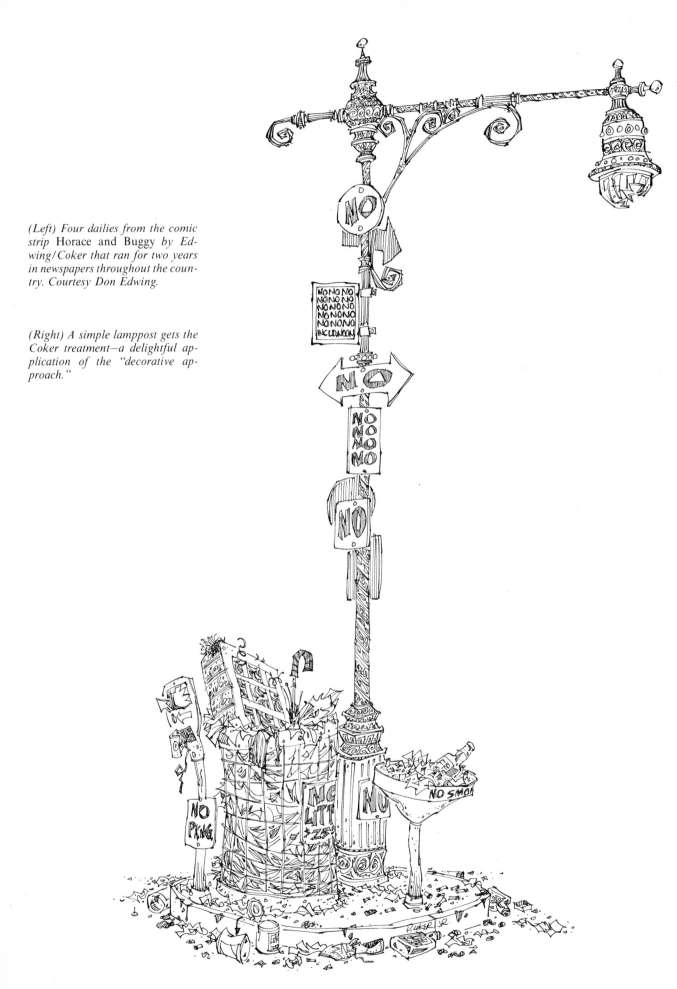

(Left) Four dailies from the comic strip Horace and Buggy *by Edwing/Coker that ran for two years in newspapers throughout the country. Courtesy Don Edwing.*

(Right) A simple lamppost gets the Coker treatment—a delightful application of the "decorative approach."

Jack Davis

Humor in Action

"I love to draw action and exaggeration because they're important to the mood of a drawing. We don't often use terms like *mood* in discussions about humorous illustration, possibly because we think it too classy or sophisticated in relation to cartoon work. If so, this is a major flaw in our attitude for it's often mood and atmosphere that help make a drawing funny—and therefore successful."

These are the thoughts of Jack Davis, one of the most prolific and best-known humorous illustrators in the field today. His posters for major films appear regularly on billboards and in newspapers and magazines throughout the country. He's done covers and illustrations for *TV Guide, Time, Life, Mad, Ebony, Pro Quarterback,* and other leading magazines. His record album jackets, paperback covers, promotional work for television networks, advertising illustrations, and animated cartoons (for both entertainment and commercials) have put his work before a vast audience. Yet despite this formidable list of achievements, Davis can be found more often on the golf course or poolside than at the drawing board. With Davis, the name of the game is speed. Deadlines are the motivating force, the pressure necessary to keep his work free and loose—the qualities for which it's most prized.

Natural looseness

"If one of my drawings looks sketchier than another," admits Davis, "it's only because I had less time to do it in, or because I got what I wanted with less rendering or detail. I don't try to give it a quick-sketched look or to contrive looseness. That would be defeating the purpose. To work fast and direct, I give the drawing a chance to grow from an unrestricted beginning: a fragmented foundation, with little or no pencil work underneath. This allows the emotion to keep the head from thinking it into the ground! And it also lets accidents happen that are often better than anything I could dream up. An action drawing implies sudden movement; my approach, I think, should go the same way."

Working rapidly has obvious advantages. Two jobs done in the time it generally takes to do one can help double your income, provided a high level of competency is maintained. Davis is certainly capable of producing a great deal of superior work, but his reasons for rapidity are more closely linked to leisure than to income. Advertising is an especially speed-oriented profession. Ad agencies are famous for using twenty-eight days out of the allotted thirty for "think tank" sessions: concept discussions, copywriting, layout planning, etc., until the artist is finally called in to face the "we need it by yesterday" routine.

Davis delivers what they want and more, then cuts out for the golf course. This ability to turn out fine work in record time keeps his name at the top of their "emergency" lists. He's had similar experiences with news publications that had to have covers featuring timely last-minute articles.

On numerous occasions Davis has completed full-color cover illustrations consisting of many figures in less than eighteen hours, pickup to delivery time. Again, Davis delivers more than a fast job. His numerous awards from several art directors' clubs attest to the quality of his work. It's both these factors—speed and quality—that have facilitated his success.

"I'm always fighting a deadline," the artist confesses. "Especially since I've gotten into advertising work. A lot of the people who call me for jobs are old *Mad* readers who remember my work and call me when they have a "crazy" job with a lot of action or exaggeration. It's almost always short deadline stuff, most of the time having probably been used up trying to convince their client that a wild, funny approach wouldn't make his business collapse. If it isn't a short deadline I put it off until the last minute and *make* it a short deadline anyway. I guess I just need the pressure. If the phone doesn't ring and guys aren't yelling at me I just kind of wander off and throw the football around with my kids.

"But I've stopped working through the night. Maybe I'm just getting older, not smarter, but the price you pay for working through the night is too high. If I get an overnight job now I give it my all, speed up a little, and take a few short-cuts I've learned through the years (like working on toned paper instead of applying the tone myself with watercolor washes). That way, I get done without working around the clock. I also save valuable time by getting

a messenger service to pick up and deliver. If the job has to be in by three o'clock in the afternoon, I can call the service at noon, tell them to pick up at two and continue to work right up until they arrive. Sometimes I'll let them erase for me while they're waiting. At least I don't have to quit work and take two hours to prepare for the trip. It's a big difference.

"I find it as hard to say No to clients as I do to friends who call me up for a few rounds of golf or a fishing trip. I once sneaked away for a few days of fishing, even though a tough deadline was hanging over me. I took the work along, planning to do it at night—and I knew we'd be in an area without electricity! I ended up doing the job by car headlight, using the water from the trout stream for the watercolor. The color looked a little strange the next morning as I drove to town to mail it in, but the client loved the "different look."

The early days

"My early drawing days were nothing special," reveals Davis. "They were like a hundred other stories you've heard. I started by copying popular comic characters like Popeye and Henry. Later on I did some work for the high school annual in Atlanta, Georgia, where I was born and raised. And still later, while stationed in Guam, I drew a Sad Sack type comic character I'd created for the Navy newspaper called 'The Boondocker'.

"After three years in the Navy, I went back home and studied art at the University of Georgia under the G.I. Bill. How strange, I thought, to study fine art to be a cartoonist. I could get just as excited looking at a *Prince Valiant* Sunday page by Harold Foster or *Flash Gordon* by Alex Raymond as I could by looking at some old master. But all the serious work—from anatomy to perspective, from charcoals to oil, from the live model to landscapes—proved very valuable later on. It certainly helped me find work when I moved to New York (I studied at The Art Student's League at night). My serious work enabled me to get illustration assignments that depended upon the knowledge, techniques, and skills I'd learned at the university. To this day I still take on occasional 'straight' illustration work when the opportunity arises. It kind of pulls me back to reality for a while, firming the foundation upon which I build my wilder, more exaggerated humorous illustrations."

One of the first attempts Davis made in trying to find a market for his work was the syndicated comic strip field. He couldn't have chosen a rougher one. Difficult to crack under any conditions, it's practically impossible when you're a non-writer, as was Davis. Most strips are bought as a package—art and script. Collaborations usually form when a writer originates a strip and gets someone to work up a few weeks of samples. Rarely will a syndicate "buy an artist" and have a strip tailored to his talents. Davis got a job inking the syndicated strip *The Saint* for about a year. He then concentrated on comic books where collaborations aren't necessary (the script is purchased on its own strength and assigned to whichever artist the editor chooses. The writer seldom meets the artist; whether their work appears together again depends upon coincidence). Davis' unique brush work and interesting use of blacks attracted editors. Before long, he was supporting himself on earnings from comic books alone.

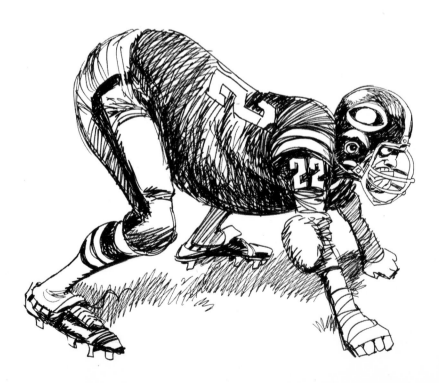

A direct fine-line marker illustration depicting the Sunday afternoon CBS–NBC rivalry for the football audience prior to the merger of the NFL and AFL.

Words and pictures

Visual people who "think with a pencil" can communicate an impression while "at a loss for words." Davis is of this genre. Like many artists he deals in sensory impressions that often lack concrete verbal definition. He can *see* a solution to the problem without necessarily being able to describe it.

Davis explains: "For an artist, showing is always better than talking. A drawing can bridge minds, miles, even languages. For example, while in Surinam with some of the guys from *Mad* we were asked to address a schoolroom of kids. They didn't know our language just as we didn't know theirs. We stood in front of the room and they just looked at these strange characters, not knowing what to make of it all. So I picked up a piece of chalk and drew a picture of Mickey Mouse on the blackboard. I figured that might break the ice, but they just looked puzzled. The teacher did his best to explain to us that without TV and movies, the kids didn't know who Mickey Mouse was. So I quickly did a caricature of the teacher. The kids broke up. The picture talked their language even though we couldn't."

The picture can also help establish communication in areas where the language is the *same*. Art directors, working on *feeling*, often put together interesting concepts or page layouts without knowing exactly what they want shown in the illustration. Give Davis a pencil, scratch pad, and a few moments of your time and you'll see it fast enough. I've personally seen him sit down with a script, read it, and start to rough out the complete story on layout sheets in a matter of minutes. The drawings are only a guide. Visual notes made from first impressions (referred to later when working out the actual spread), they are remarkably incisive and funny. The temptation is always to let Davis ink them right then and there, and start him on a new story entirely.

Feel the material

Davis prefers pen to brush, but finds that the brush is faster. His choice depends upon the work.

"I associate brush work with comics," offers Davis. "When I'm doing a job that needs a comics look, like *Superfan*, or a comic-like brochure for an advertising agency, a #3 or #4 Winsor & Newton red sable watercolor brush is the only thing. My brush technique is a carryover from comic book days, and I can pencil and ink a three-page *Superfan* episode in an afternoon. With a pen it might take me a whole day."

A brush line is very fluid and definite, making its statement boldly and economically; the thick and thin effect is achieved through minimal hand pressure variances. The "feathering" technique (thick to thin parallel strokes emerging from a line or blackened area) is an effective manner employed to suggest the turning of form. Comic book or Sunday comic section features are never colored directly on the original. The artist or a colorist employed solely for that purpose indicates which color goes where on black and white photostats or page proofs. The actual color separation is done at the printer's shop. Davis' pencil work for jobs that will *not* be finished in pencil is done with Venus H pencils sharpened in a handy electric sharpener. This stage of the work, no matter how wild or zany the subject, is done cleanly and directly onto the finished stock. There are no fuzzy multiple "searching" lines. The forms are accurately

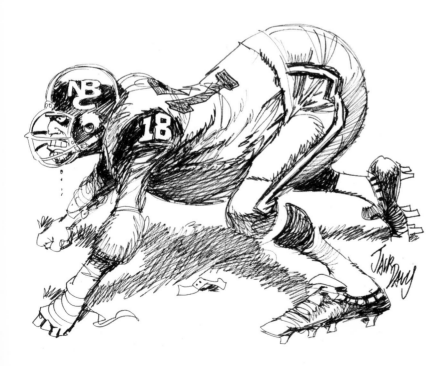

defined and leave no question as to what has to be done. Pen work is generally done with any crowquill nib and any brand of India Ink (Davis being of the "closest thing gets used" school). He does prefer Pelikan sepia ink for washes rather than diluting black ink to wash consistency. Davis attributes this preference to his oil painting class at the university where sepia oil washes were used as underpainting. His color technique is of the same traditional nature; he applies color glazes with colored inks or Grumbacher solid watercolors until the desired tones and values are achieved. He adds the highlights last, mixing watercolor with white tempera or perhaps with Prismacolor colored pencils. He utilizes the texture from the pencil in some passages, but dilutes it with clear water for others. Acrylics have been added to Davis' wide range of techniques and he doesn't hesitate to use all the techniques at his command at any time. His comment when questioned about colored markers, "I like 'em—they're fast," was to be expected.

Action and exaggeration

A successful action drawing is more than an illustration depicting movement. There should be at least a hint of what could or will happen—or what couldn't or won't happen—as a result of the action. This implied conditional action adds drama and excitement to the scene as well as prolonging the picture's timing. A football player, for instance, runs through the scattered bodies of opposing players to face a giant lineman. This tells us where the player has been, what he's done, where he is now, and what might happen if the opposition gets him. This scene can be depicted in one illustration, combining both the implied future and past with the specific present.

"I exaggerate action in a drawing to clarify as much as to entertain," explains Davis. "When you push the action a little more in the direction it's already going, the reader becomes more aware of what's happening. For instance, in a western saloon brawl scene I'll make sure my figures have an exaggerated follow-through when throwing a punch. I'll show molars flying and wigs flying off the head and really demolish a chair over someone's head. It's funnier because it's burlesque. Chairs don't crumble when they come in contact with a noggin—the noggin does! And that's not funny, it's gruesome. And not very likely to get people to laugh. Not *normal* people, anyway.

"Even when drawing a figure in a rather quiet pose or setting (like a newscaster for *TV Guide*) I exaggerate the pose. I draw the feet longer and out of proportion with the rest of the body, etc. Needless to say, I exaggerate his features, as would any caricaturist. I try to set the same mood this person usually sets when you see him, but with a light touch."

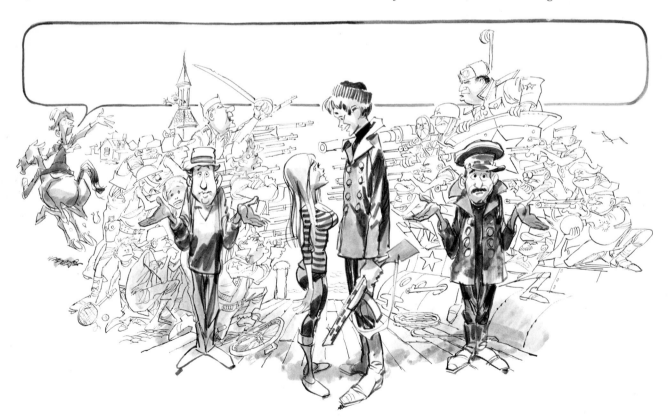

Two brush and sepia ink wash roughs for the movie "The Russians Are Coming, The Russians Are Coming," designed by Davis and used as posters and newspaper advertisements.

Research and reference

Illustrators generally rely on their reference library (or "morgue") for pictorial research. Cutting and filing systems are as elaborate as the artist. Albert Dorne, legend has it, owned a picture collection worth tens of thousands of dollars that consisted of over twenty full filing cabinets!

It would be easy to assume that some humorous illustrators used no reference at all, especially those involved with gag panels (the difference between a Cadillac and a Lincoln is not easily definable in a few, quick brushstrokes), but in assignments for specific markets, even a gag cartoonist must know or learn his subject. "There's a difference between a place-kick and a punt!" angry readers of a football magazine will assert in the "letters" pages.

Davis is fortunate in that he possesses a visually retentive memory. His recall of course is best in subjects he's personally interested in.

"Usually, when I see something, I can remember what it looks like," adds the artist. "I've got an 'instant replay' mind that kind of snaps pictures of actions and details that I can put into my work. I don't have what you'd call a reference file, but I refer to my *World Books* and *National Geographics* when I've got to do something I know little about or show a place I've never been to. As far as western, Civil War, and sports subjects, I have a lot of that up in my head.

On the other hand, the client usually supplies source material for subjects requiring particular accuracy: photos of people I have to caricature, magazines featuring machines, or whatever. But since so much of my work is exaggeration I burlesque the picture anyway. For instance, if I get a jetliner story to do, I can remember movies I've seen and planes I've been on and draw an impression of the real thing. Because most people don't have total recall, my impression isn't too different from theirs of what a pilot's uniform looks like. And how many people have really been inside a cockpit? They imagine it's very complicated-looking—they have an impression from movies and TV that it's filled with dials and buttons and gadgets. So I draw in this intricate stuff, giving that impression, even though in reality the plane I drew could never get off the ground!

"Of course it helps if you've actually experienced the thing you're drawing. When I draw football scenes, for instance, I recall the days when I played for school teams and how they ran all over me! I know what it's like to be a skinny kid running into a three-hundred pound lineman. I *felt* the crunch so I can *draw* the crunch a little better." A track star in his youth, Davis has successfully applied his talent for speed to his drawing. Time, experience, and determination haven't slowed him a step—they've only given him a level of quality that will keep him up front always.

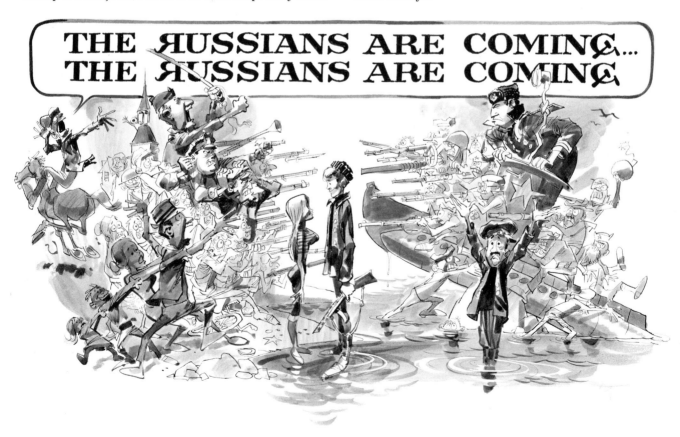

41

II—The Offensive Team

The Offensive Line

You'll find the fan of football knows
The names of all the high-paid pros,
But naming the Offensive Line
His memory will rarely shine;
It's time we praised this faceless bunch
Who hold the fort and take the crunch;
Their names are er, ulp *(choke)*, ahem . . .
Well, one day we'll come up with them.

The Wide Receiver

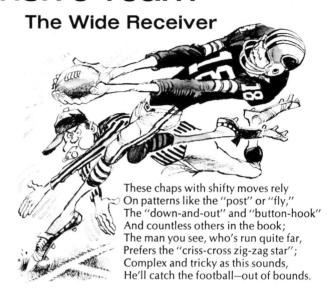

These chaps with shifty moves rely
On patterns like the "post" or "fly,"
The "down-and-out" and "button-hook"
And countless others in the book;
The man you see, who's run quite far,
Prefers the "criss-cross zig-zag star";
Complex and tricky as this sounds,
He'll catch the football—out of bounds.

The Quarterback

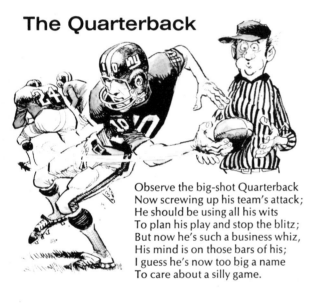

Observe the big-shot Quarterback
Now screwing up his team's attack;
He should be using all his wits
To plan his play and stop the blitz;
But now he's such a business whiz,
His mind is on those bars of his;
I guess he's now too big a name
To care about a silly game.

The Running Back

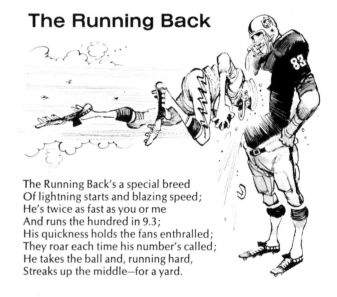

The Running Back's a special breed
Of lightning starts and blazing speed;
He's twice as fast as you or me
And runs the hundred in 9.3;
His quickness holds the fans enthralled;
They roar each time his number's called;
He takes the ball and, running hard,
Streaks up the middle—for a yard.

The Fullback

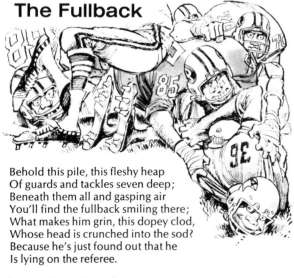

Behold this pile, this fleshy heap
Of guards and tackles seven deep;
Beneath them all and gasping air
You'll find the fullback smiling there;
What makes him grin, this dopey clod,
Whose head is crunched into the sod?
Because he's just found out that he
Is lying on the referee.

The Place-Kicker

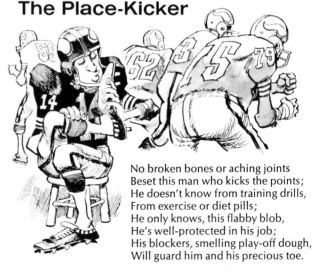

No broken bones or aching joints
Beset this man who kicks the points;
He doesn't know from training drills,
From exercise or diet pills;
He only knows, this flabby blob,
He's well-protected in his job;
His blockers, smelling play-off dough,
Will guard him and his precious toe.

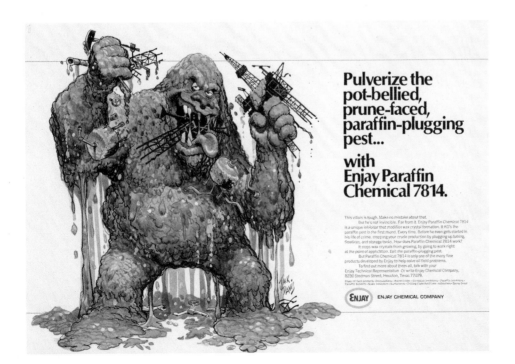

(Above) A watercolor-on-toned-paper rendering for a magazine article dealing with the comparative scoring ease of the place-kicker.

(Left) A full color ad executed in brush, colored ink, and acrylic. Courtesy the Enjay Chemical Company.

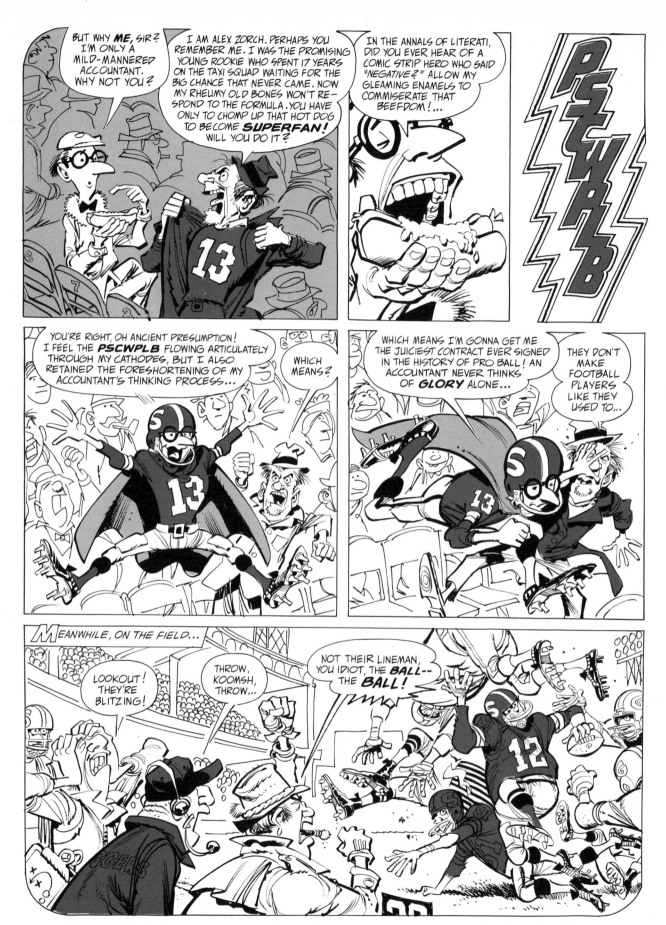

A typical page from the Superfan *football feature by Meglin/Davis as it appeared in the pages of* Pro Quarterback Magazine. *Originally printed with comic-style flat color, the work was "translated" into two tones of gray for the* Superfan *paperback published by New American Library.*

Cels from the TV animated ad for 'Lectric Shave produced by Focus Productions. Both are reproduced on acetate from the artist's original pencil drawings. The reverse side of the acetate is then colored with special acetate opaque colors to avoid covering over any of the line work. Courtesy J.B. Williams Company.

The upper drawing of Big Sid as created by Focus Productions for the TV animated Utica Club commercial is direct pencil on lightweight bond paper. The lower drawing has been reproduced on acetate traced by another artist from Davis' original, shifting the elements to create another cel in this walking sequence without losing the flavor of Davis' concepts. Courtesy D.K.G. Advertising.

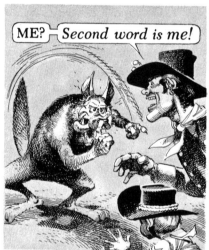
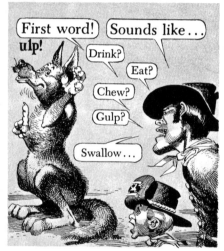
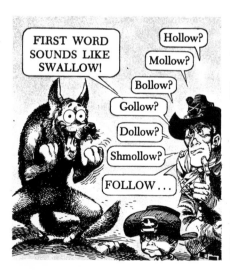
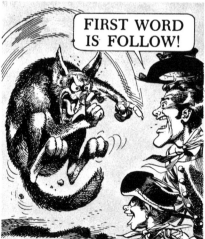

A highly exaggerated and spirited sequence from the Rin-Tin-Tin satire as it appeared in Harvey Kurtzman's Trump Magazine, *a short-lived satirical "slick." Reprinted with permission of Playboy Enterprises Inc., successor in interest to Trump, Inc. (© 1965 by Trump, Inc.).*

Even in a "portrait," Davis distorts the features of the head so that it obviously spells out "Ice cold water!" in this ad presentation.

A finished pen and ink drawing (right), a rough pencil cover design (below left), and a finished pen and ink cover design for a humorous children's book (below right). Courtesy Harcourt Brace Jovanovich, Inc.

In the beginning baseball was played bare-handed.

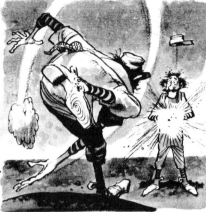

This gave rise to many styles of catching.

It also gave rise to many styles of hands.

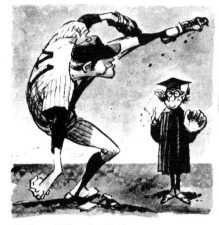

Today all baseball players use gloves.

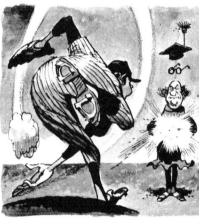

A player needs a glove to protect his hand and improve his game.

But mainly a player needs a glove on the hand that's going to catch the ball.

Tom Seaver

Tom Seaver Autograph Model Fielder's Glove

Lucky for you, in 1895 a guy with sore hands named A. G. Spalding decided that catching a baseball without a glove was strictly for the birds. So he invented a glove. It was small and black and had no padding.

Spalding (which by the way has made *every* baseball ever played in the majors) has been manufacturing and improving baseball gloves ever since.

SPALDING

Through exaggeration, Davis effectively illustrates the humorous text created by Allan Jaffee (whose chapter, The Artist/Writer, begins on page 88) for this successful Spalding *magazine campaign. Courtesy of The Spalding Company.*

Mort Drucker

On Caricature

"There's more to caricature," begins Mort Drucker, "than drawing a humorous portrait. The resemblance is achieved by capturing the features, but it's the subtle nuances of a person—little highly individual touches—that breathe life into the work. I don't believe a caricature begins and ends with a face: figure, stance, attitude, expression—all add up to recognition. We can tell our friends or family members from strangers even when we can't see the face, and you can often spot someone you know by his walk. I have a special interest in hands. They tell a whole story in themselves. By matching the expression of the face with the correct hand gesture you can give the work more meaning, dimension, and humor than you can by just capturing a good likeness."

Drucker is not of the "lollipop" school of caricature, which consists of drawing the head and sticking it on a body—any body! A "lollypopist's" oeuvre will reveal that the figures are interchangeable. Some attempts may be made to broaden the girth of a heavy personality or stretch the frame of a tall one, but the effort ends after these cliché elements are incorporated.

From the beginning, Drucker considers the *total* person rather than the isolated parts. The personality starts to emerge even in his first quick, rough pencil notations. Though mere ovals serve as heads in this early stage we can, for example, distinguish a Jason Robards Jr., from a George C. Scott. For even here, Drucker's astounding feel for the individual shows through: despite the crudity of the preparatory sketches, suggestions of Robard's long, narrow face are evident, as compared to Scott's broad forehead and Romanesque features.

The face

While the varied physical properties of an individual help establish total caricature, one's face remains the prime recognition factor. We are, of course, an eye-to-eye communicative society, responding to vocal stimuli by direct confrontation. The same holds true of the printed page. We "read" the face as we read the words.

For this reason, exaggeration for exaggeration's sake is not the way to accurate caricature. A dedi-cated caricaturist does more than draw big noses. He *reconstructs* the head to make all his exaggerations work together, placing in sharpest focus those features he believes best capture the personality.

"We all have the same features," states Drucker. "It's the space between them, their proportions and relationships to each other that distinguish one face from another. I let features swim around the facial area until I feel they've been arranged properly and the spacial relationships are right."

Photographs: aid, not answer

Drucker doesn't copy or trace photographs, but he often uses them for research, as a basis for his work. They also serve to remind him of what he has personally observed from movies or television. A keen observer, he retains many visual responses. Drucker studies the expressions and nuances of a person much as a Rich Little, Frank Gorshin, or other impersonators would, basing their mimicry on a level deeper than mere speech imitation. Drucker gets to the heart of the character and works diligently to maintain his graphic likeness.

The vision of the artist can in some ways be truer than that of the photograph. This brings to mind Picasso's retort when criticized that his portrait of Gertrude Stein didn't look like the famed writer: "Never mind," the artist said, "in the end *she* will look like the *portrait!*" Picasso's explanation was more than playful. He knew he'd captured his subject as he knew her through their friendship. Subsequently, Miss Stein did indeed "grow" into the resemblance. The portrait, painted about the turn of the century, is perhaps the most definitive study of Gertrude Stein ever executed.

Learned by doing

"I'm extremely fortunate," states Drucker, "in that everything I know about caricature I learned through professional experience. There were no months of study or books to study from—and even if there had been, there was no time for it. The assignment was there, calling for humorous rather than "straight" likenesses, and I had to deliver as any other profes-

sional artist would. After the job was accepted and paid for, I said 'Hey! I can do caricatures!' And that was that. I didn't realize at the time it would turn out to be the most important facet of my work and career."

Like many others who specialize in continuity illustration (telling a story through a panel-by-panel technique as opposed to a single illustration), Drucker began his career in comic books. And, like so many others in this field, his dream at the time was to "graduate" from this notoriously ill-paying field to a syndicated daily and/or Sunday feature newspaper. While a syndicated strip doesn't guarantee financial independence, it at least allows those involved a royalty arrangement whereby their incomes increase concurrent with the popularity of their work. This concept, of course, serves as an incentive to keep work at the highest possible level. Comic books, on the other hand, paid by the page. With the exception of a few rare individuals, each artist was paid the same page rate, depending upon the company. In this setup, *speed* rather than *quality* becomes the factor that decides income. Quality becomes a very relative term. A six-page story, for example, cannot be judged by the work alone, but by the level an artist can maintain while still trying to earn a living.

Comic books are enjoying a new wave of interest and high sales. However, as long as the "pay by the pound" policy prevails, quality work will be delivered by a talented few who have the ability to turn out good work at a rate of speed that still enables them to feed their families. Drucker worked under such conditions, but found it very hard to derive much pleasure or satisfaction from his work. He marveled at a Joe Kubert, an Alexander Toth or a Jack Davis, whose work, he felt, was the quintessence of comic book art.

Limitations of being self-taught

"If I had it all to do over again," claims Drucker, "the only change I'd make would be attending art school or a university with a good art department. Being self-taught means being limited by your innate talent, personal experiences, and influences. You try to learn through imitation, and while some growth is possible in this manner, it depends upon the expertise of the artist that you emulate.

"Art teachers, professional instructors, and most of all your fellow students, make you more aware of the *thinking* end of art which is a lot more difficult to learn by yourself. I went to Erasmus High School in Brooklyn, New York. There were no courses designed for the serious art student, so my parents encouraged me to attend art school after graduation. I tried Parsons School of Design for a while, but the emphasis was on art direction and similar areas far removed from what I was looking for."

There's a popular advertisement that reads: "I got my job through the New York Times"; Drucker did just that. His first professional art job came about by answering an "art assistant wanted" ad. Drucker

The opening spread of "The Oddfather" movie satire. Drucker uses wash more as color than as a way of turning the form. The faces show little if any tone and stand on the pen work alone. Reproduced by special permission of Mad Magazine *(© 1972 by E.C. Publications, Inc.).*

worked on backgrounds for a syndicated strip for six months. He left because the job had no future, but had learned enough about the field to land a new job in the art department of *National Periodicals*, where he worked for three years. Drucker's main duty there was to correct other artists' work. He had to imitate many styles and use varied techniques to keep his work consistent with the original. This also meant that he had to tackle the many subjects comprising *National's* comic magazine line: western, adventure, love, war, and the cartoon features.

The constantly changing problems and varied styles involved were very helpful to this aspiring cartoonist; Drucker wanted to learn and broaden his art. He was later able to secure from the company freelance assignments that he worked on at night and on weekends. As his work improved and became popular, Drucker was finally able to realize the first of his major goals by leaving salaried employment to become a fulltime free-lancer.

Drucker's greatest success was in a humorous line of comics featuring the fictional adventures of famous comedians: Bob Hope, Jerry Lewis, etc. His ability to capture these personalities with a few brushstrokes impressed editors and started him on the road to caricature. Now, Drucker needed an assistant, so his wife Barbara learned to wield the eraser and white-out paint.

As Drucker's markets broadened, so did his influence. When assigned straight illustrations for *Bluebook* and adventure and sport magazines, he found inspiration from the work of the leading illustrators of the day, Robert Fawcett and Austin Briggs. For humorous assignments he studied the action and exaggeration of Albert Dorne's figures. For caricature he turned to the work of Ronald Searle, the brilliant English artist, and Al Hirschfield, theatrical caricaturist in the Sunday *New York Times*. This amalgamation enabled Drucker's own personality to surface more confidently in a distinct style all his own.

Working directly

Drucker doesn't think out his ideas on paper. He doesn't do thumbnail sketches. He prefers instead to envision the completed work in his mind beforehand. He later duplicates the concept on paper as best he can, allowing accidents and changes that may possibly improve the work as he goes along. Drucker finds drawing directly and committing his idea to paper in a one-time hit-or-miss approach can generate more excitement and originality than permitting the pencil to wander over the page in search of a visual solution to the problem. "It's also a sure way to keep from being too influenced by your research," reveals Drucker. "I put the figure in where I think it belongs and not where the photo dictates. Staging an illustration around available reference points limits your freedom to tell a story effectively; when an artist does that, he ignores his very purpose."

Working directly is not necessarily a timesaving procedure. While the composition is thought out

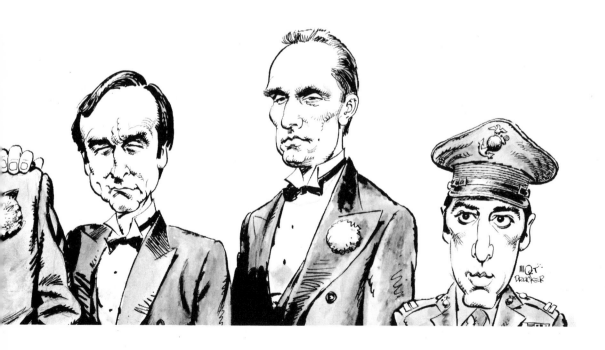

carefully, not all inherent problems are obvious from the start nor are they easily solved cerebrally. The artist must still work diligently to transfer mental image to working surface. This can be just as (if not *more*) time-consuming as doing a series of rough preparatory sketches.

One of the most important factors in direct drawing is *selectivity*. In humorous illustration, especially, care must be taken to clarify the point or message of the work. Extraneous material, no matter how well drawn or how attractively executed, will hurt more than help the drawing if not handled subtly. Anything that calls attention away from the main focus or distracts the reader is best underplayed or left out entirely. Drucker will sometimes use pencil, for example to illustrate the background of a panel, while executing the foreground figures or the composition's focal point in pen. The tonal washed-out quality of the pencil work serves almost as a backdrop for the action at center stage.

Pen, ink, and radio

Drucker prefers to work on 2- or 3-ply Strathmore illustration board. The heavier stock permits extensive use of washes and transparent color, the artist's favorite methods, with a minimum of paper buckling. The high-quality finish also allows for frequent erasures without spoiling the surface of the paper—a very necessary consideration for most artists who prefer to work direct.

Drucker is essentially a pen man, preferring the Gillott line of flexible pen nibs for their ease and constant flow. He does not care for the rigid quality of crowquill points. He finds they dig into the paper, spatter, and do not move as easily across the page when a quick, flowing line is desired. He has found Artone's Fine Line India ink to be well-suited to his penwork, switching over to Artone Extra-Dense black for large areas to be brushed on with a Winsor & Newton #2 or #3 red sable watercolor brush.

Drucker did most of his early color work with colored pencils that can dilute and mix with water. He then began using Pelikan colored inks in addition to the pencils. Ultimately, he used the inks almost exclusively (with perhaps a few touches of diluted pencil for special effects). Dr. Martin's dyes were then added to the palette and, finally, Winsor & Newton watercolors in solid form (at this writing, this is the artist's favorite color technique).

My radio is "as important as my drawing equipment," declares Drucker. "I always work with it playing in the background. Most of the time I'm not even aware I'm listening. It's just a way of touching the world outside while putting in long hours of relative isolation. But then, months later when I see my work in print, I can recall exactly what I was listening to when I penciled in this head or inked in that figure. It's a crazy way to remember things. I only wish it worked as well for remembering birthdays and anniversaries!"

Drucker likes to keep the eye moving in and out of his "organized chaos" scenes, picking up a personality in the foreground, dropping back for a glance at a nobody—or is that a somebody?

Objectivity

Drucker tries to remain objective when drawing his subjects. Yielding to the temptation to compliment those you admire or be purposely unflattering to those you don't will limit your artistry. Any obvious or heavy-handed attempt at ridicule will insult your audience, even those of similar persuasion. Actually, you may end up defeating your own aim. There's a "root for the underdog" attitude prevalent in this country. An "I don't like the guy either, but that's going too far" response to your work might be all that's needed to push someone over to the other side.

A caricaturist is also a journalist. With the exception of political cartoons, he's responsible more for reportage than opinion. Respecting the readers' intelligence and allowing them to form their own opinions is always the most effective educational process.

Drawing continuity

Continuity, such as a movie satire in *Mad Magazine* or an animated commercial of a celebrity, presents some of the most difficult problems in caricature. The artist cannot create one definitive study, as in a caricature that might appear with accompanying text or on a magazine cover. Rather, he must capture the likeness in panel one; then again in panel two in a different angle, pose, and composition; then again in panel three, and so on for as many as six or seven panels per page for perhaps six or seven pages.

Drucker will often include a distant shot, a silhouette, or some other change of pace to allow both the reader and himself a rest.

"To keep the character looking like the same person throughout," suggests Drucker, "I study how the dominant features react in key expressions. If the lip curls in a particular way, or the eyes narrow more than usual while smiling, I can construct the head in various poses and still maintain a consistency in the likenesses despite little or no research in these new poses. It's always surprising to see how many photographs of people don't actually look like them. In a collection of movie stills from any one film you're sure to find several shots of an individual whom had you not known who it was you wouldn't be able to recognize. If I draw my characters that way—staying completely true to the reference material—it would be thought a bad job. That's why I try not to depend solely upon photos. Being an accurate copier doesn't insure good likenesses. A caricaturist, like a portrait artist, deals not with reality, but with images reduced to line and/or tone on a two-dimensional surface."

Mort Drucker does something else, too. He adds an appealing quality, a style, that brings his two-dimensional surfaces to life. He's a warm, sensitive man whose caricatures are created to delight, not offend. Mix this with his remarkable talent and you have a recipe for success.

OPERA NEWS

VOL. 31/NO. 17 TROVATORE FEB. 18, 1967/35¢

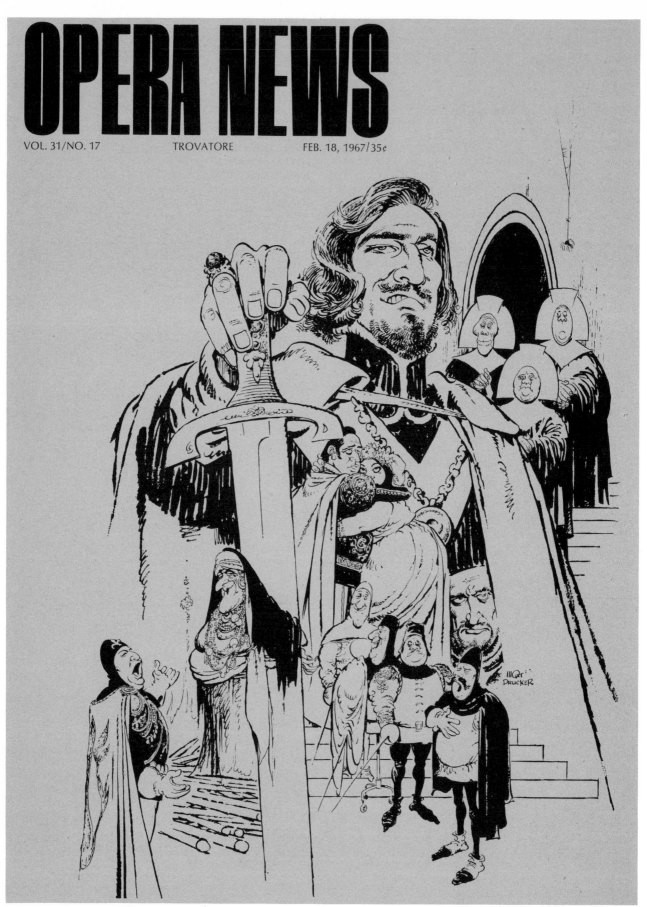

Even as specialized a publication as this is not too conservative to have a little fun within its own area. Here, Drucker creates the characters from Verdi's Il Trovatore *from imagination, but manages to sneak in a subtle caricature of Robert Merrill as the main figure, aware that the baritone is famous for his portrayal of Count di Luna. Courtesy* Opera News.

The two stars of the movie "True Grit," Kim Darby and John Wayne, get the full Drucker treatment. His caricatures don't begin and end with the face—the figures tell just as much about the actors or the roles they play. Reproduced by special permission of Mad Magazine *(© 1970 by E.C. Publications, Inc.).*

This drawing and the one opposite are two of a series for a campaign that packed personalities, linked by a central theme, into the composition, sardine-style. Courtesy Combined Insurance Company of America.

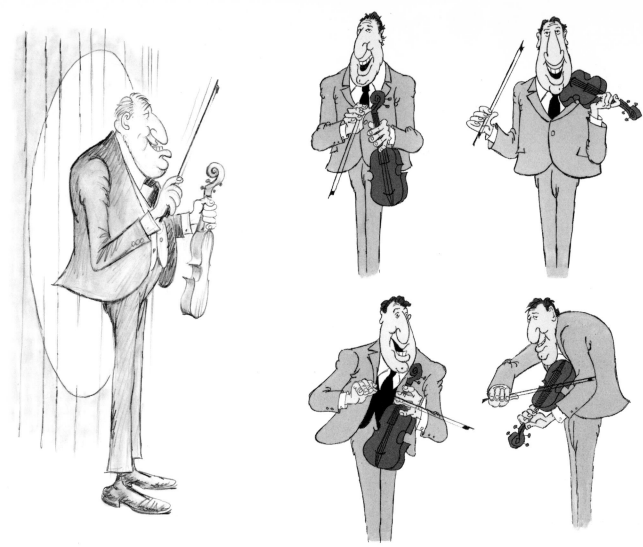

In this animated TV ad produced by Focus Productions, Drucker designed the key cels of this highly stylized caricature of comedian Henny Youngman for the Utica Club "Heckler" sequence, using pencil and wash to indicate tone. Courtesy D.K.G. Advertising.

The "splash panel" of a Gilbert and Sullivan burlesque features President Nixon and cabinet members with a song on their lips. Reproduced by special permission of Mad Magazine *(© 1972 by E.C. Publications, Inc.).*

A black and white poster design for the James Bond movie adventure "Casino Royale." Here Drucker uses black as color, spotting it effectively and attractively throughout the composition.

(Overleaf) Drucker was called in to design a border of celebrities to commemorate this company's seventy-fifth anniversary. Courtesy Billboard Publications, Inc.

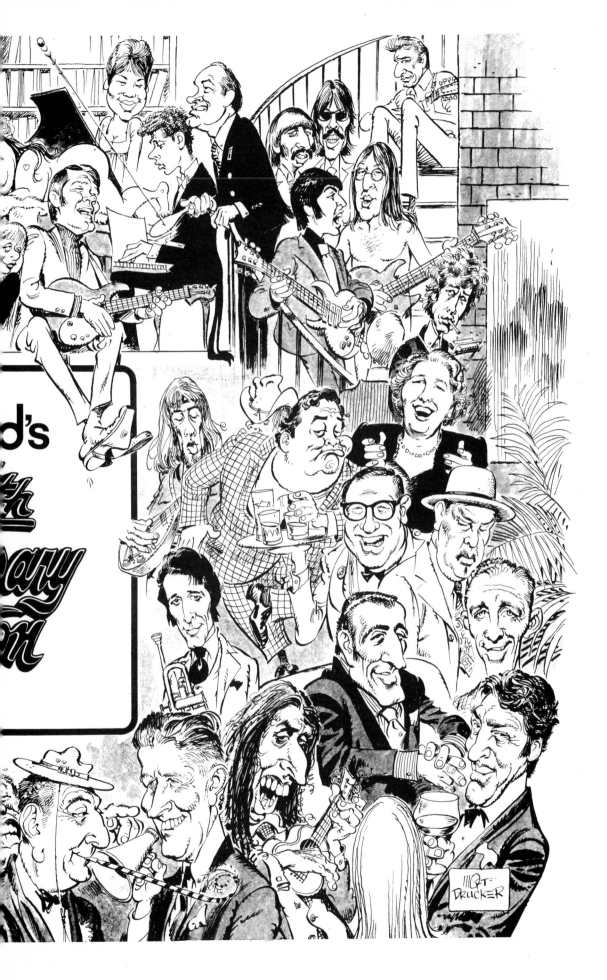

Gerry Gersten

Advertising and the Humorous Illustrator

"Getting fired can be a wonderful, thrilling experience," says Gerry Gersten. "For me it meant the difference between continuing on at the same level, producing one ad after another (ad infinitum) in the same manner or approach that had proved successful before: no growth, no development, much boredom (ad nauseum). Naturally, I was terrified when that notice came. Getting the rug pulled out from under you is always frightening. But looking back over the years following that horrible/wonderful day, it's obvious that it represented life to me as an artist—not death."

While Gersten speaks personally, his words carry a much broader message. Not that he is advocating getting fired as the only way to succeed. What he is suggesting is an honest reappraisal for the professional and student alike; a long, uncomfortable look at directions and goals, and a comparison between early ambitions and present achievements. The artistic society is no different than any other in that *success* is the hallmark. The inherent danger of success is repetition. It is always easier to follow proven paths than to clear new ones. That's how trends are formed and why styles are copied. When the followers do it, it's not half as bad as when the initiator resorts to copying himself. The creative, innovative person must move ahead or sink in his own wake.

"Many times you're asked to repeat yourself," Gersten emphasizes, "and it's difficult to refuse when your livelihood is dependent upon client demand. There you are: you're tired, deadlines are hanging over you, you can use the money. So, you rationalize, why not give the man what he wants—and you give him what he wants! But the truth of the matter is, you'll *always* be tired, you'll *always* need the money, and hopefully, there'll *always* be deadlines hanging over you. Of course, you don't realize you're in a rut at the time. You're comfortable: not making moves, not taking any risks. Perhaps for the first time in your life you're relaxing and enjoying success. Well, that's the way it was for eight years at the studio I was attached to. Then a budget cut-down forced a few of us over the ledge. For me, it turned out to be an upward fall."

Avoiding ruts

It stands to reason that any artist not sure of what he's doing or where he's going is forced to dip into all his resources, not just those already proven successful. Full potential may never be reached unless there's a definite impetus, which is why lack of experimentation can be detrimental to the creative person.

There are times when most of us can use a kick in the complacency. We're more often than not the worst judges of our own efforts, achievements, progress, or lack of same—which is why such a thing as a rut can happen. Revelation must come from within, but it often receives its initial charge from a more objective observer, be it friend, peer, loved one, or tough art director. "Fortunately," states Gersten, "I've worked for that kind of art director—Herb Lubalin. He was a tough taskmaster, and because he insisted upon and accepted only your best work, he got just that. Sure, you'd curse under your breath, but that inner voice way down there somewhere would be whispering to you as you made your changes (or complete new start) 'C'mon, you know the guy's right!' Lubalin was a terrific influence for me and a lot of other guys in this field."

Drawing for emotional expression

By now, "I've been drawing since I was a little kid," has become a cliché. You hear it whenever artists talk about their backgrounds. What we all forget, or fail to realize, is that *all* kids draw! It isn't until they're older, facing more of life's pressures and developing the restrictions and inhibitions of the adult world, that most children drop this outlet for emotional expression. Those who don't, usually become artists of one sort or another, or at least find work in some related field.

"Drawing," Gersten recalls, "was the only area I excelled in as a child. I was just about average in everything else, so the way I earned the pat on the head so important at that age was to draw. I guess that's why I'm still drawing today. My formal art training started at the High School of Music and Art [New

York], followed by Cooper Union. Cooper was a great school. I learned a lot, but it took me some years to *forget* a large percentage of what I learned there. Everyone was so completely dedicated to being 'modern' that they tended to put down traditional solutions without knowing why. I didn't care for Norman Rockwell; I lavished praise upon Piet Mondrian because I felt I was supposed to: curves were out, corners were in. Of course, this was no fault of the school. The desire for change, the wish to do something revolutionary and new, is part of growing up. Yes, I put down Rockwell; now I love him—and I don't think as much of Mondrian as I used to.

"Lately I find my character drawings are increasingly similar to those I drew at age twelve. I like this. It indicates that at least some of the observations of the young, innocent, 'primitive' me took hold."

Character

Due to the very nature of advertising—selling something to someone—the advertising artist's work (humorous or representational) must contain that enigmatic value known as *appeal*. The potential buyer must not be turned off. His response to the message must remain positive, which is why more and more humor has been injected into the advertising field. Very often, the humorous illustrator is employed to maintain the current popular philosophies of "entertain them as you sell them" or "if you make them laugh, they'll love you." Or perhaps the "show them you're down to earth and not a snob" approach while selling unquestionably snob-appeal products. Whatever the reasons, the humorous illustrator is appreciative of new areas opening up to his talents. Since the soft-sell deals more with people than product display, Gersten attempts to create characters that are immediately recognizable, concentrating on types and personality traits that will say the most about someone in the least amount of time—and say it well.

"When I get an assignment to do a character," Gersten explains, "I try to make him as universally 'readable' as I can. I try to create a symbol so that the

Here Gersten employs an outline technique, typical of nursery rhyme illustrations and consistent with the premise of the ad. Courtesy Pfizer Laboratories Division.

66

viewer feels he knows this person; perhaps they've met somewhere, or the reader's reminded of his Uncle Fred. I work to build up a strong individual whom everyone recognizes. When putting together a face or expression, I often go back to old films I've seen. The English really know themselves. No character is a blend in their movies. Each one is usually a well-defined, *well-drawn*, instantly recognizable symbol. I try to achieve that quality in my drawings.

"My reference sources (besides old films) include film picture books and movie stills, which I collect. I also collect old Sears Roebuck and Montgomery Ward catalogs, as well as costume books. The *Horizon* and *American Heritage* series are great for this; they're full of pictures. I also keep a well-stocked picture file (or 'morgue,' as it was once called). The folder labels read something like this: *Figures, Men, Figures, Women; Children*, etc. In rummaging through the file I often find an idea or a suitable staging. I select research information and then arrange, change, bend, or do whatever is necessary to tailor it to my needs."

Using tracing paper for finishes

Techniques and drawing materials are as varied as the artists using them: each has his own favorite tools and unique methods. Gersten's method for much of his work is interesting in that he uses tracing paper for finishes as well as for the preparatory stages.

"I work mostly on a medium-grade tracing paper with soft graphic leads ranging from 2B to 6B," says Gersten. "For years I used standard wooden pencils and an electric pencil sharpener. Before that I used to whittle the point sharp with an X-acto Knife, and soon found the whittling was so pleasant that I spent more time sharpening pencils than drawing. Now I use loose leads in a mechanical drafting pencil. I also use a round 6B graphic lead in a Hardmuth holder. This is almost a magic pencil. I couldn't begin a job without it, and it seems to do all the work for me. Tracing paper is perfect for pencil drawing because it reproduces a nice black for line jobs, and has a good spontaneous look when reproduced in halftone.

"My pencil drawings on tracing paper are often

This award-winning poster appears here sans color and greatly reduced in size from the giant dimensions it was designed for—without loss of impact. Courtesy Newsweek Magazine.

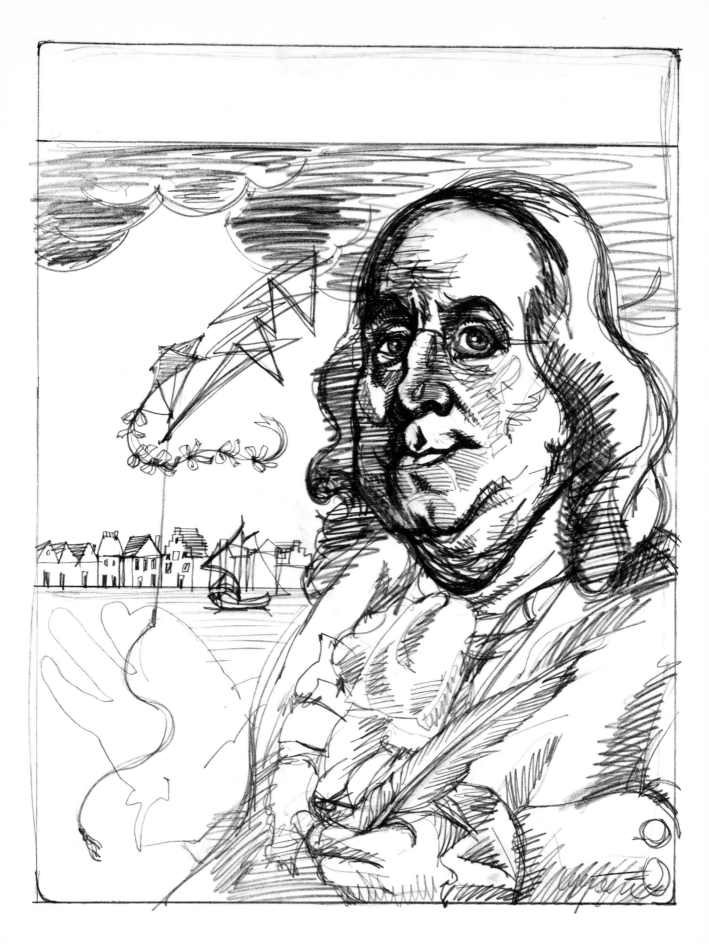

A loose pencil/tracing paper rough for an ad depicting Benjamin Franklin. Gersten would normally trace over this sketch directly, tightening it up considerably and then dry-mounting it for better presentation and subsequent reproduction.

thought to be pen and ink jobs. However, when an assignment calls for a 'traditional Dickens look *à la* Cruikshank,' I use a crowquill pen on very fine drafting vellum. At first, mounting tracing paper with rubber cement on board was tricky. It was never really permanent, and the cement eventually discolored the paper. Happily, I've since discovered the electric drymount machine. Years ago, in a non-air-conditioned studio, dampness created many unpredictable and sometimes happy accidents. These accidents inspired me to experiment with water, dyes, and washes on tracing paper. The results are still unpredictable (and not always happy), but they're often interesting. "When mounted properly, tracing paper takes color beautifully in dyes, designers colors, casein, and acrylics. At one time, production men refused finishes in pencil; my work consisted mostly of photostated pencil drawings with color added. This problem no longer exists."

Drawing for specific readership

Gersten generally derives enjoyment from his drawing assignments, especially those which enable him to develop characters, such as his work for pharmaceutical advertising concerns. Here the artist is not dealing with executives who consider their market the lowest common denominator (as many in standard advertising consider the general public, proven by a plethora of tasteless, condescending television and print ads). Pharmaceutical advertising is aimed not at the broad populace, but at a more intellectual, sophisticated readership; doctors, pharmacists, etc. Hence, Gersten found the working atmosphere in this particular area freer and less inhibiting. "They went along with approaches that were imaginative as well as humorous," Gersten explains. "They realized that the impact of humor, even on life-and-death subjects can be a very positive force when handled with taste and discretion. They encouraged experimentation and entertained concepts and styles that many other kinds of advertising would never consider. Obviously, I enjoyed that special challenge."

Art vs. photography

Arguments concerning photography and illustration still go on and probably always will, although they make little sense. The differences and similarities between the two are countless and are always subject to discussion. What remains a constant, albeit simplified, comparison is what is expected of each process. Photography *records* that which is put in front of the lens; illustration *creates* what it wishes to present. Both can portray truth, opinion, distortion, feeling, drama, interest, history, and of course, humor.

The commercial photographer offers a "no-risk" solution to the advertiser's problems. No matter how the subject is arranged or lighted, the intent or purpose of the photograph is clearly defined. The message is obvious. No matter how creative the man behind the lens, he's limited to the photographic image of reality that we've grown to accept as the definitive statement. The illustrator, on the other hand, is all risk. You never know what you're going to get: a completely new set of ideas and images comes with each artist—and therein lies his strength. His personal vision, his approach, the wide range of media at his disposal, his ability to take visual licenses with change, or expand upon a writer's ideas or an art director's concepts—these are the areas that separate illustration from photography; these are the areas the artist should explore to fulfill his proper role. Perhaps more interesting than the differences between the two processes is how each can assist the other, with the photograph providing factual images that the artist can interpret.

Artists, discovering its practicality, have used photography in a variety of ways since its earliest days: witness Degas and Eakins. Degas was so intrigued by the unconscious acceptance of cropped figures and objects found in photographs that he began to employ the practice in his canvases, cropping foreground subjects in an innovative way; Thomas Eakins' photographic experiments with the figure in motion were a major contribution to the camera arts of his day.

The process can be reversed. Federico Fellini, who has graced this volume with a foreword, uses his sketches as guides for his cameramen, costume designers, makeup crew, set builders, etc., while advertising agencies throughout the world employ storyboard men to visualize sequences that will be filmed live in final presentation.

Structure

The artist deals in a world of illusion. He creates the facsimile, the representation, the suggestion of reality. The humorous artist must interpret this illusion in a way that elicits a joyful response. The underlying graphic image of all artists, however, is essentially similar: no matter how exaggerated or stylized in treatment, the drawing must stand on a firm foundation.

Gersten doesn't spare the fundamentals in laying the foundation for his drawing: "I always look for *structure*. I find endless ways in which to draw a thing, but the artist's visual understanding of how an object is put together, how it's built, is the basic prerequisite for good drawing. He must know how an arm feels under a wrinkled blanket, how a head sits on a neck, or how a plant grows. He must know the structure of everything from furniture to flowers. We can see how a thing is built and how it grows in nature, but structure and growth also exist in nonrepre-

sentational drawing and sculpture. Once you understand how a thing is made—and how it works—and can relate its separate parts to the whole, you'll have that much better a chance to do a good drawing."

Growth and experience

Many artists confuse growth with experience. It doesn't necessarily follow that someone who has gained a great deal of experience has grown. All too often the opposite happens. It is how experience is used that determines growth or the lack of it.

A professional artist must use his experience to develop confidence so that he can experiment and develop new approaches to old problems. He must broaden his mental as well as his graphic vision. Answers learned from previous situations should aid, not solve.

Style, technique, media—these are aids, not solutions. Growth is not the ability to handle the pen with more precision, for instance, but to have the confidence to handle it with *less* precision if the final result will be more expressive. It sometimes takes guts to draw *naturally*, however contradictory that may sound; art fads and trends are temporary plateaus at best.

Gerry Gersten has recently turned to three-dimensional humor, handling assignments that can be easily satisfied by pen and pencil with wood and papiermâché because "it's new, different, and exciting." What better reasons! Gersten has always been interested in growth, and he achieves it by not compromising his approach to his work. This exacting attitude is evident in every job that bears Gersten's signature. And that's what growth is all about.

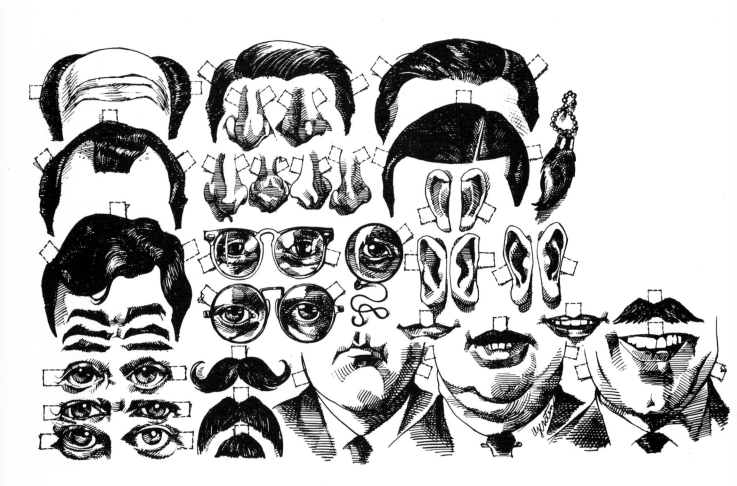

A montage in the pencil/tracing paper technique previously described. Courtesy Newsweek Magazine.

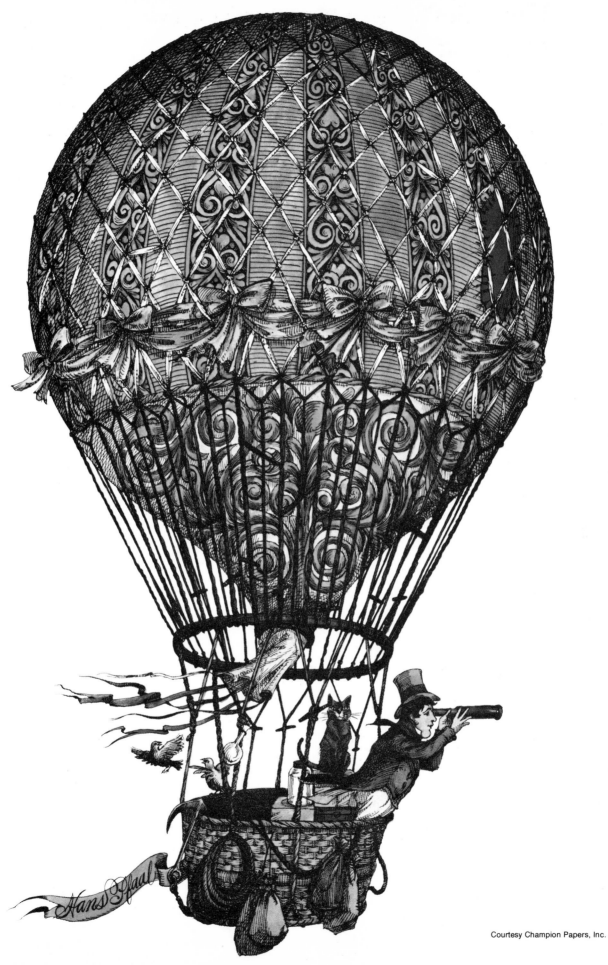

Hans Pfaul

71

If you can't find a Meyrowitz store near you, maybe you need glasses.

Farley Gibnowsky directed this year's big low-budget film, *A Niceness in Sodom*. Farley was film critic for *Fertilizer Topics*. He shot *Niceness* for $40 on the roof of his garage and superimposed the whole thing on old Leon Errol short subjects.

His next project is a musical entitled *The Middle Ages*. Farley picked up his shooting glasses at the **Meyrowitz 1168 Madison Avenue Store (near 86th)** because it's right near Elaine's where he lives while he's in New York.

Cindy Trendy, super-wow model. She just did the first white nude cover for National Geographic. She is currently appearing in five TV commercials, on 27 magazine covers and *Ladies Wear Weekly* is dedicating a whole issue to her.

She spends lots of time at the Salvation Army buying *shmatahs* which she resells for outrageous prices at her chichi boutique, *Cindy, Mindy and Boopsie*. She got her rhinestone-studded, blue-tinted, plastic frames at the **Meyrowitz 1098 Third Avenue Store (65th)** which is every bit as trendy as Cindy.

Moira Erstwhile, Westchester Matron and Fem Liberationist. Wrote the smash bestseller, *The Female Satyr*. She cooks, sews and raises her children between appearances on TV Talk Shows and marching in parades (with the VFW, she was a WAC during the Korean War). Last week, Moira threw the first Conservative Chic party in White Plains.

She got her 14-carat gold grannies at the **Meyrowitz 278 Mamaroneck Avenue, White Plains Store.** Moira states forthrightly, "If Ogden Nash had known about Meyrowitz, he wouldn't have written those nasty things about girls who wear glasses."

Serafina Myrrh, advertising wonder girl. She wrote the legendary Crypto Seltzer commercials and the award-winning Trans-Kansas Airline campaign, "The beginning of the Inane Plane."

Serafina recently left the E. Pluribus Arnhem Agency with an art director and account man to set up her own shop, Gold, Frankincense & Myrrh, which is located in the Copywriter's Hall of Fame. She bought her nifty, very large-framed specs at the **Meyrowitz 555 Madison Avenue Store (near 56th)** where all the advertising biggies gather to compare lapels.

Charlie Fender, cab driver par excellence, holds the world's speed record between 14th Street and 86th Street—he did it going uptown on Second Avenue to avoid bucking traffic. (The fare went into permanent shock.)

Charlie got the "Hack of the Year" award from the guys at Spindlemeyer's Garage for triple parking in front of the **Meyrowitz 520 Fifth Avenue Store (near 43rd)** during the rush hour while getting his dynamic horn rims fitted. As Charlie puts it, "Meyrowitz is my kind of place because they make great glasses and they're convenient."

Sam Carsgrove is Long Island's ninth largest used car dealer. Last month he wheeled and dealed 3 Kaisers, 2 Hudsons, a clean De Soto, a creampuff LaSalle and a World War II Jeep ("Lady, you'll be proud to drive a car that served its country!").

He claims he can smell a deal 100 yards away. Now that he's got those very contemporary French-made frames with slightly tinted lenses, from the **Meyrowitz 1552 Northern Blvd. Manhasset Store,** he's happy because he can see them too.

Art Kunst, the famous gallery owner. He started the trend to Abstract Repressionism in the 50's, the Plop Art craze of the 60's and is now pushing Calender and Marginal art that's driving the Beautiful People crazy. (The Scrolls just paid him 35 thou for an Andy Gargoyle Tryptich titled "Mom and Dad and the Kids and Aunt Pru Eating Tuesday Dinner.")

Art just left for the Toledo Biennial, held alternately in Spain and Ohio, to see what's new over his half-glasses. He got them at the **Meyrowitz 839 Madison Avenue Shop (near 70th)** located in the very nerv. center of gallery land.

Aquariana Katz, Long Island revolutionary. She disappeared from her parents' home six months ago to join a cell called the Mudville 9. They were planning to turn around all the road-signs on the Long Island Expressway to ruin business in the Hamptons next summer.

Only time she's been home since then was to pick up those unusual metal-elipse-within-an-octagon frames at the **Meyrowitz Half Hill Shopping Center Store in Stony Brook.** She says, "I hate the establishment, except where my eyes are concerned." Aquariana, if you're reading this ad, please call your mother.

Dow Johannes, bright young financial wizard. Personally underwrote 29 public issues. Spun off 14 companies last week and is merging them into 14 other companies this week. He set up his own mutual fund in Monaco then sold it to the Government of Yugoslavia for 12 billion *Zlotys*. He's now waiting for the *Zloty* market to turn around.

Dow got his neat, metal-framed glasses at the **Meyrowitz 150 Broadway Store** in the heart of the financial district. Dow says, "I need very good glasses because, lately, I'm crying a lot."

Great looking medicine for your eyes. "Meyrowitz OPTICIANS, INC. ®

(Left) The Gersten pencil technique is well suited for newspaper reproduction, the graininess of the pencil work aided by the texture of the newsprint stock. Courtesy E.B. Meyrowitz, Inc.

(Above) One of a series of drawings the artist designed to illustrate the "nose speech" from Rostand's Cyrano de Bergerac for Eston Laboratories.

He almost flunked his Viennese Krunch course because his brothers were always eating his homework.

© Barton's Candy Corp., 1988

They copped his krunch again, and guilt was written all over their chocolate-covered faces. He was learning the candy trade too well for his own good.

All he had left was bare, brown paper candy cups and the thought of facing the old Viennese candy master empty-handed. He'd never be promoted to raspberry rum cordials this term. It was all their fault.

As a punishment, his mother threatened to take away their desserts for the next six months.

Fortunately, one of the culprits preferred mama's homemade apple strudel to candy, and immediately confessed

that he had neatly stashed away five pieces of krunch in the back pocket of his tweed knickers.

The next day the boy candy major shakily presented those five perfect nut-studded squares to the Colonel of Krunch.

Lucky for him, candy masters from the Old School were more concerned with quality than quantity.

So he got the highest mark in the class and went on to graduate with a B.C.(Bachelor of Candy).

That was forty years ago.

Today, he's Barton's head candy maker. He's still faced

with candy-snatching of a sort, but it no longer threatens him.

"Copying the Barton's look is as easy as stealing candy from a baby," he says. "It's the ingredients that are a trade secret."

He makes over 300 types of candy. From the Viennese Krunch of his childhood, to mocha petits fours, floating almond cordials, creamy French truffles, strawberry marzipan, and even TV Munch.

Each one has its own secret recipe which he's not about to tell anyone. Especially not his brothers.

BARTON'S
bonbonniere
NEW YORK · LUGANO, SWITZERLAND

Abigail Heartburn, schoolmarm, gets "nervous indigestion" over...

Gersten has found specialized pharmaceutical ads to be among the most receptive for experimental illustration. Courtesy A.H. Robins Company.

(Above) Gersten has successfully "illustrated" several assignments by creating three-dimensional, papier-mâché portraits and figures.

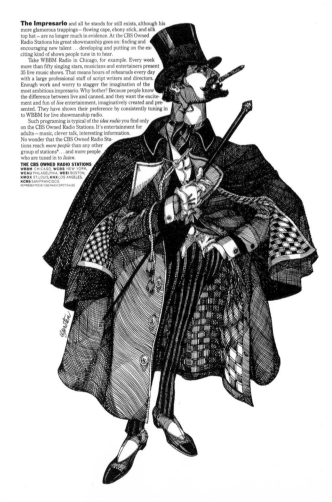

The Impresario and all he stands for still exists, although his more glamorous trappings—flowing cape, ebony stick, and silk top hat—are no longer much in evidence. At the CBS Owned Radio Stations his great showmanship goes on: finding and encouraging new talent . . . developing and putting on the exciting kind of shows people tune in to hear.

Take WBBM Radio in Chicago, for example. Every week more than fifty singing stars, musicians and entertainers present 35 live music shows. That means hours of rehearsals every day with a large professional staff of script writers and directors. Enough work and worry to stagger the imagination of the most ambitious impresario. Why bother? Because people know the difference between live and canned, and they want the excitement and fun of *live* entertainment, imaginatively created and presented. They have shown their preference by consistently tuning in to WBBM for live showmanship radio.

Such programing is typical of the *idea radio* you find only on the CBS Owned Radio Stations. It's entertainment for adults—music, clever talk, interesting information. No wonder that the CBS Owned Radio Stations reach *more people* than any other group of stations* . . . and more people who are tuned in to *listen*.

THE CBS OWNED RADIO STATIONS
WBBM CHICAGO, **WCBS** NEW YORK, **WCAU** PHILADELPHIA, **WEEI** BOSTON, **KMOX** ST. LOUIS, **KNX** LOS ANGELES, **KCBS** SAN FRANCISCO.
REPRESENTED BY CBS RADIO SPOT SALES.

(Right) A beautifully rendered pen drawing as it appeared in the ad (greatly reduced here) and, on the page opposite, as it reproduced from the original. Courtesy CBS Television.

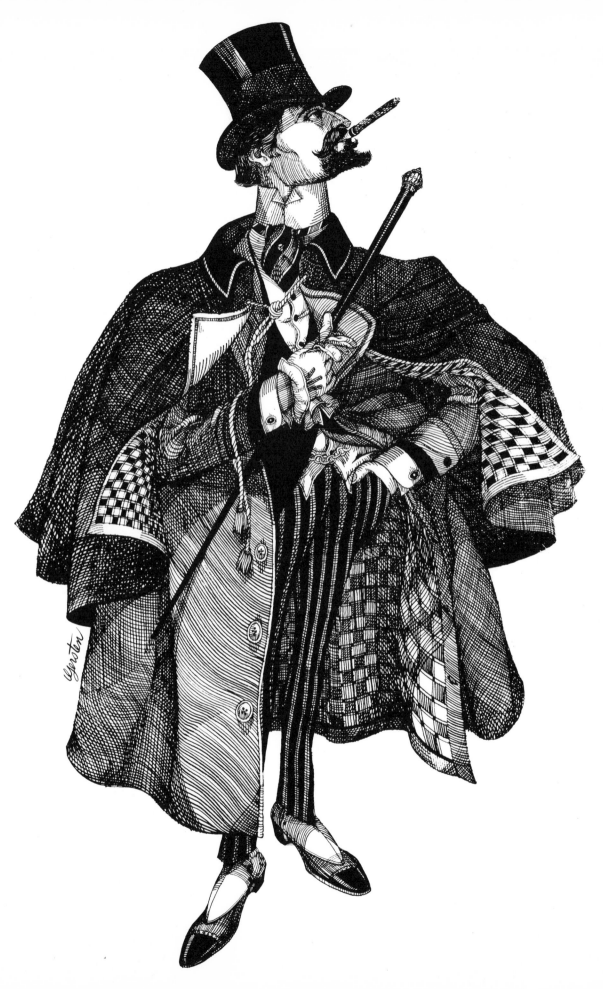

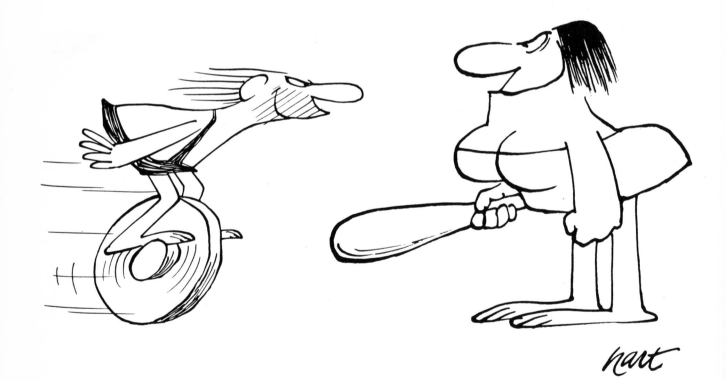

Johnny Hart

The Comic Comic Strip

"The comic strip field is an exciting one," offers Johnny Hart. "It's made up principally of people who've refused to grow up and who offer their marvelous fantasies to people who *wish* they hadn't."

The comic strip is unique in that it's basically an American art form. Like everything else in the world, it didn't just miraculously appear; it evolved. Its influences and growth stages were, for the most part, also American contributions. The comic strips' popularity was enormous from the outset, appealing to all types and classes of people: presidents spoke fondly of their favorites, not in the least fearful they would be judged less intelligent. If anything, they were seen to be "more human," which, politically speaking, didn't hurt their image one bit.

Comics establish a beachhead

In 1896 *The Yellow Kid* appeared as a Sunday feature, ostensibly for the younger readers. While there were one or two predecessors to this new journalistic form, none had the impact or the following *The Yellow Kid* enjoyed. Thus, Richard Felton Outcault's creation is universally accepted as the beginning of comics. As adults also began to accept and enjoy the early strips, syndication of these features soon brought them into many more homes, and of course an even greater following resulted. For the most part, strips were designed to be the "funnies," as they were commonly called. Humorous and soft-stepping, they depicted domestic *life*, but seldom domestic *strife* in the actual sense.

In the late 20's and early 30's the adventure strips brought a new dimension to comics: **Tarzan** leaped from vine to vine as easily as Buck Rogers leaped from planet to planet. When Max Gaines (father of William Gaines, publisher of *Mad Magazine*) put together reprints of popular Sunday features into a soft-cover, inexpensive magazine, *comic books* were born. The books added yet another outlet for what is now considered one of the most popular forms of entertainment and education.

There was never much competition between the adventure variety of comic strip and the humorous—there was more than enough room for both. For every *Flash Gordon* reader there was a *Blondie* reader—usually the same person. And while *Terry and the Pirates* kept followers up-to-date on the Far East air war in the early 40's, *Gasoline Alley* kept the home fires burning with slice-of-life characters (who actually aged) involved in adventures with which readers could identify.

Different strips rose and fell in popularity as moods, values, and society itself went through changes. But I doubt that any strip ever captured the imagination of the public as completely as Charles Schulz's *Peanuts*. After a slow start, it later seemed that anything Schulz touched turned to gold. Charlie Brown took over the world and Snoopy went to the moon (literally). Whether the world-weary public was anxious for the funnies to become funny again is a topic for psychological researchers, but certainly the climate was right for humor strips that reflected the wit and sophistication of modern society. Johhny Hart sensed this, but didn't feel a mirror image was the best way to accomplish the job. He felt that a more primitive setting could best point out the absurdity of contemporary life, and what could be more primitive than primitive man in primitive times? While much of the humor of *B.C.* is anachronistic, its time-out-of-joint qualities make it that more absurd, pointed, and downright hilarious. Hart's second creation, *The Wizard of Id*, is cut from the same pie—its Middle Ages panorama is often as modern as tomorrow.

The liberated comic strip

Innovations are not easily come by. This is not necessarily as much the fault of the creator as it is the market for which he creates. Editors and syndicate heads are loathe to change a successful formula, and second-guessing what the public will accept and reject is part of their daily function.

The "language" of comics has been founded by the strips themselves. Almost every popular feature attempted to originate or introduce expressions, fads, or fashions that would be associated with the strip and thereby gain immeasurable publicity. Some succeeded in doing this very well: spinach became synonymous with Popeye, the "Dagwood sandwich" became world famous, and "Dinty Moore's" became a popular name for any "corned-beef-and-cabbage"-serving tavern, thanks to Jiggs. Phrases like "Balls-o'-

Fire" from Snuffy Smith, "Egad" from Major Hoople, and, of course, "Good Grief!" by Charlie Brown served their creators well. Comics gave birth to other expressions that found their way into the vernacular of their own time, most notably "twenty-three skidoo," "the cat's pajamas," and "hot dog."

Johnny Hart's contribution worked in reverse: he sought not to create but to *reflect* the language of his time. A "dip" in the road was not a small indentation, but a *dip* (a shlub, jerk, or clod, ethnic words that mean pretty wild things in literal translation). He fought an uphill battle for years, finally winning the right to call the females in *B.C.*, "broads"—despite the acceptance of the term in books, movies, and even the generally conservative TV. Hart goes one step further in some cases. When a character pays "3 clams" for something in the strip, he actually pulls three shellfish out of his loincloth, thereby literally translating a slang expression. Alcoholism, no longer a taboo subject for most entertainment media, was seldom shown or spoken of in the sterile world of comics. Hart responded by creating a character for *The Wizard of Id* who's never sober! His motivation is neither to shock nor create controversy, but to call the shots as he sees them.

How some strips are born

"Like so much in life," philosophizes Hart, "the things you often work and plan for go nowhere, while others slip in through the back door and become the most important events in your career. That's the way it was with both *B.C.* and *The Wizard of Id*. When I found it almost impossible to support wife and self from my income as a gag cartoonist, I took a job in the Art Department of General Electric, relegating cartoon work to nights and weekends.

Greatly inspired by the success of Charles Schulz's *Peanuts*, I decided to concentrate on a comic strip. I loved doing caveman gags, but had had no success with them in the gag market. One of my G.E. cronies kiddingly suggested I do a "prehistoric strip, inasmuch as you can't seem to sell them anywhere else!" So, I did! *B.C.* was rejected by five major syndicates before it was accepted by Harry Welker at the New York Herald Tribune Syndicate.

"Two years after *B.C.* began, I created *The Wizard of Id*, which was to lay dormant thereafter for an additional four years. The realization had hit me that if I did sell the strip, it would be nearly impossible for me to write and draw twelve dailies and two Sunday pages a week. Finally, when I decided that *The Wizard* was too good to be filling up a drawer, I thought of my old friend Brant Parker.

"I asked Brant to fool around with some of the characters I had originated and gave him a few gags to illustrate. One look at his work and I knew I'd made the right decision. We worked in a New York City hotel room for three straight days and nights, taping the finished dailies to the walls as we completed them. On the morning of the fourth day, with just a few more hours of work left, I phoned the syndicate. To our surprise, they arrived a few minutes after. The ink wasn't even dry on some of the pages. Brant, barefooted and shirtless, was sipping coffee; I was in my shorts shaving off a three-day beard. The men from the syndicate edged their way around the room as they looked at the work, kicking aside an occasional coffee cup or beer bottle.

"When they'd seen everything, we picked our laundry off the chairs and everyone sat down. 'Well, what do you think?' I asked. 'We think *you're* disgusting, but the *strip* is great. We'll take it!' It wasn't long before *The Wizard* had as many papers as *B.C.*

"Even with Jack Caprio working full-time and Dick Boland helping out on a free-lance basis, two strips are still a lot of work. When people ask me what my hobby is, I tell them 'working on weekends.' When they ask me my goals, I tell them '*not* working on weekends!' "

Writing two strips

"There are bound to be similarities when one source produces two separate entities," says Hart, "no matter how diverse the subjects. It always makes me laugh when I hear people putting down a composer for writing something that sounds like an earlier piece, as if he could shut himself off from himself and become someone else. If the work is visceral, whether it be Wyeth's painting, Steinbeck's writing, or Bernstein's music, the man's personality has to emerge. 'It reminds me of something else he did' shouldn't be a value judgment—just descriptive."

Hart is quick to admit to the similarities of *B.C.* and *The Wizard*, often creating a gag sequence for one and later applying it to the other because: "it worked better when performed by the other cast." This is possible because both strips share a common basis—they parody today by yesterday.

Perhaps the greatest difference between the two strips, other than the drawing styles and the era in which each is set, is the focus of each: *B.C.* deals with the foibles and follies of man; *The Wizard* is concerned with personalities working within the framework of an established society. In the latter, the King can personify any authoritative figure, from mayor to president. An election gag in *B.C.*, on the other hand, has to be set up with, as Hart laments, "three days of build-up gags before we get to it. Sometimes the build-up gags are better than the one that started the whole thing off. If they're not, we can drop them all and use the one gag that does work in *The Wizard* because the society is already set up . . . sometimes, not always."

What makes both strips work so successfully is

the prime ingredient in all humor—timing. Any continuity gag, especially the standard one-two-three panel format of the daily strip, sinks or swims on the writer's ability to create proper timimg for the gag and the artist's ability to maintain it visually. If the writer is also the artist, or at least a visual person, so much the better.

"Snowballing"

The *B.C.* characters started out as rather simple creations for their caveman setting. "But they weren't real enough," recalls Hart. "Why don't you use your friends as models for the characters," his wife Bobbie suggested. "No, I've got a better idea," countered Hart. "I'll use my friends as models for the characters." Which he did. And continues to do. "Some are exaggerated a bit, some aren't—and I won't say which," Hart says with a wide grin. "I've been a lot happier with the strip since recharging the characters, and judging from the readers' response, they are, too."

The Wizard characters are based more on types than on individuals. This enables Hart to inject ideas that different—sometimes opposite—factions can react to. "I'm not on any soap box," states Hart, "and I'm not trying to present one opinion or point of view. To the contrary, the wider the spectrum of feelings, the more potential there is for humor. The King in *The Wizard*, for instance, has *no* personality. We tried to capture the blank expression of the king from a deck of playing cards. If he's no one in particular, he can be *anyone* the situation suggests."

Ideas for both strips often generate from Hart's "snowballing" approach. When working with Parker, Caprio, and Boland, whether individually or in concert, each member contributes another element to a randomly chosen situation until something happens. "Someone might say 'dungeon,' " explains Hart, "another 'wine,' a third will add 'dragon,' and from this a situation of a dragon in a dungeon with a wine cask might develop. If it doesn't go anywhere after a few minutes, the snowballing starts again, continuing until we come up with something satisfying. These gag sessions are really fun. Sure, it's hard work, too—but it's also lots of laughs. We don't try to finish gags at this point, just put down those ideas we know will work and have the potential for a strong sequence. Sometimes the concept is so right that the ideas are practically finished. When that happens we can write as many as two weeks of strips in an hour."

Daydreaming

"Daydreaming is another great source of ideas," continues Hart. "When I'm working I never stop my mind from wandering. Like a bouncing ball, you never know where it's going to land. As I stare out the window, a truck might go by—a phone company truck—and suddenly all the frustrations I've had with the telephone rush out, and a new sequence is developed."

Hart is aware of today's social consciousness and attempts to "say something" while being funny. Social comment alone is not the answer for him; he mixes significance with slapstick in a masterful blend. But Hart avoids an out-and-out intellectual

The B.C. *cast of zany characters.*

approach because this "tends to be wordy. I try to reduce everything down to its simplest form. It's more entertaining, and the message still gets through."

Simplicity

In the overall composition of a gag, the design of the writing is one element to consider; the balance of the drawing and the writing is another. Too many lines, whether written or drawn, can stop the flow, obscure the point, and hurt the gag. It is therefore worth taking time and effort to simplify the drawing. Simplifying is more than *leaving out*, it's knowing what to *put in* and how to do so without calling attention to it. As Bill Mauldin states in his foreword for one of the paperback collections of *B.C.*:

"The easiest picture in the world to draw is a cluttered one. Comic artists who fill every square inch with detail are known as 'rivet men' in the trade, from the fact that they put every rivet on every boiler. What does it matter if the hero is a little offside in the panel? Stick in a computing machine with hundreds of dials, or a tree with every leaf. Nothing dazzles the customers like drawing every leaf on a tree. But place two unwashed cavemen against a horizontal line, which could be the top of a swamp or the bottom of an overcast, or against a sloping line which could be the side of a hill or the edge of a rainbow, and you'd better place them right."

When humor is reduced to its basic elements, it transcends even language barriers. As Hart has learned: "I know when a *B.C.* sequence is especially successful by its inclusion in foreign humor magazines. A gag based on man's vulnerability—and making its point visually—translates into any language. That's what makes pantomime the purest form of humor."

From start to finish

B.C. and *The Wizard* are drawn on prepared stock, a 3-ply, kid finish Strathmore board that has each strip's title printed in black at the top and guidelines printed in blue to the exact dimensions of the strip. The ink used for the blue guidelines is invisible to the platemaker's camera, a convenient and timesaving device that allows the artist to concentrate on the drawing and forget the technicalities.

Hart uses a standard #2 writing pencil to rough out the strip. He allows for dialogue balloons initially, then indicates the characters and background loosely. The strip is now lettered for the finish with India ink. Hart begins to ink directly over his rough figures with an Esterbrook #788 nib and a Winsor & Newton #4 red sable watercolor brush for solid black areas. "After doing these characters for so long," Hart reveals, "I don't have to follow careful penciling. Besides, I think it gives the inking stage more excitement. The work becomes static when you carefully apply ink to a pencil line to make it suitable for reproduction."

After the ink is dry, Hart goes over everything with a kneaded eraser. He makes most of his corrections with a double-edged razor blade. "A double-edged blade is very flexible," the artist offers. "By bending it in the middle you can achieve a mini-gouge effect that's perfect for slicing the ink off the surface and really getting into corners. I don't recommend this method for thin paper." Larger areas or ink smears are corrected with Pro-White, an opaque white watercolor (in jars) that spreads easily with brush and covers exceptionally well.

The continuing cycle

"One of the nicest things about success in one's chosen profession is meeting some of the people you've admired from afar. Cartoonists Dick Cavalli, John Gallagher, and Bill Brown were all heroes of mine. Today, they're my friends!"

Johnny Hart proved his ability by creating one of the most successful comic strips of his time. He then proved it was no accident by creating a second strip as popular as the first. Out there in the hinterlands, perhaps reading this chapter right now, sits a hopeful cartoonist who admires Johnny Hart from afar. If he dedicates himself to his work—as Hart does—and has the confidence to see beyond the hurdles and rejections—as Hart did—the cycle will continue.

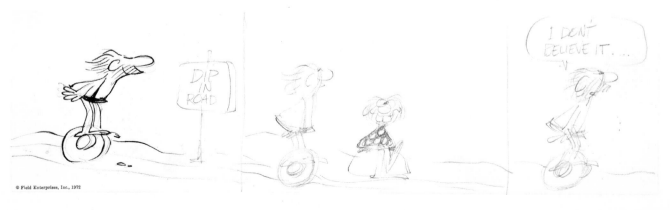

© Field Enterprises, Inc., 1972

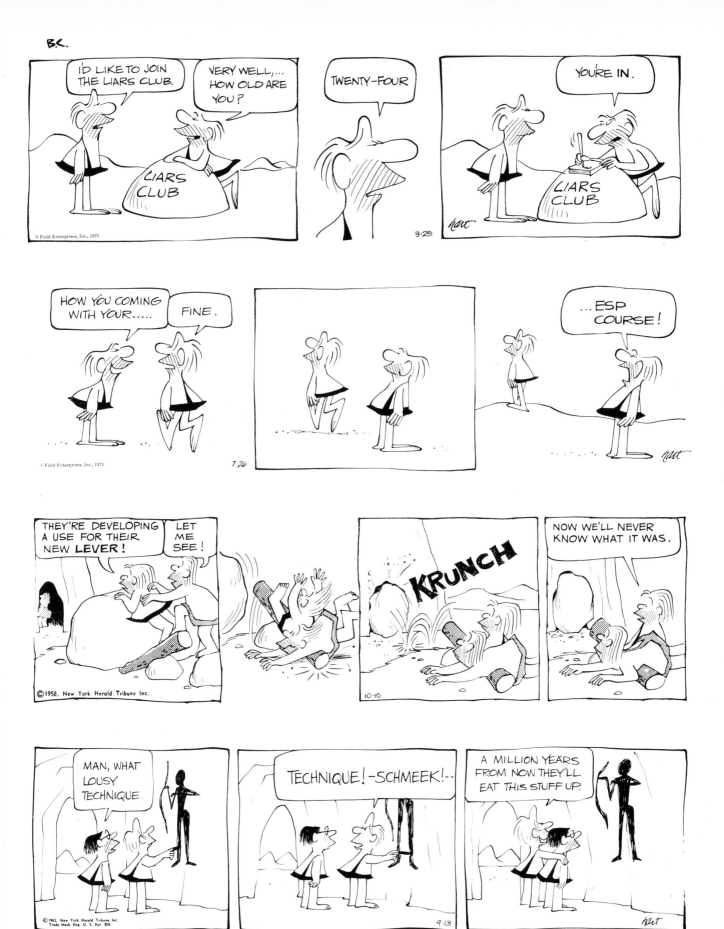

(Left) A typical daily strip showing the loose pencil underdrawing and the free pen application of the India ink. See some finished strips above and on the following pages.

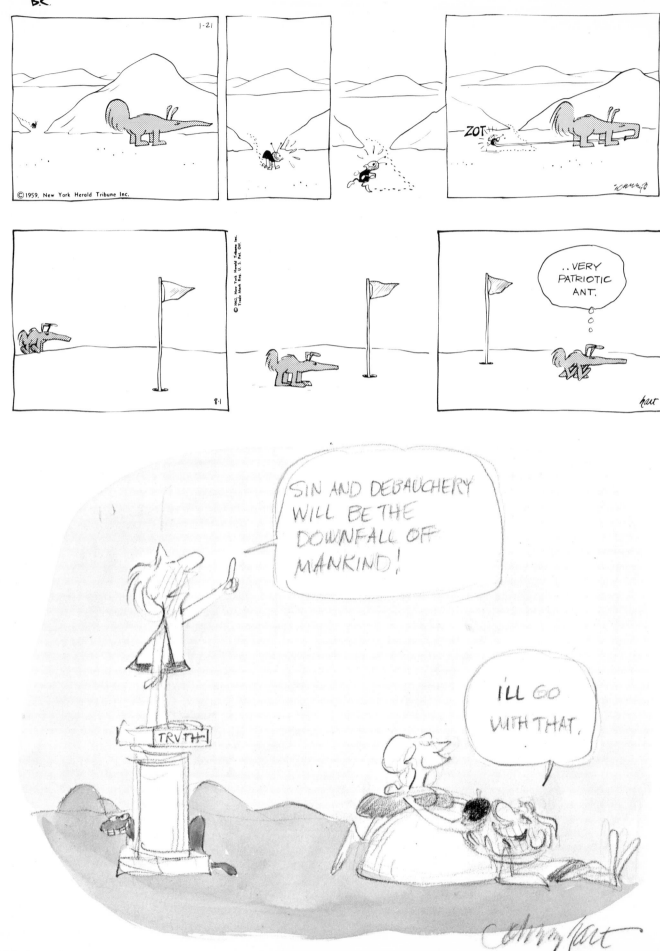

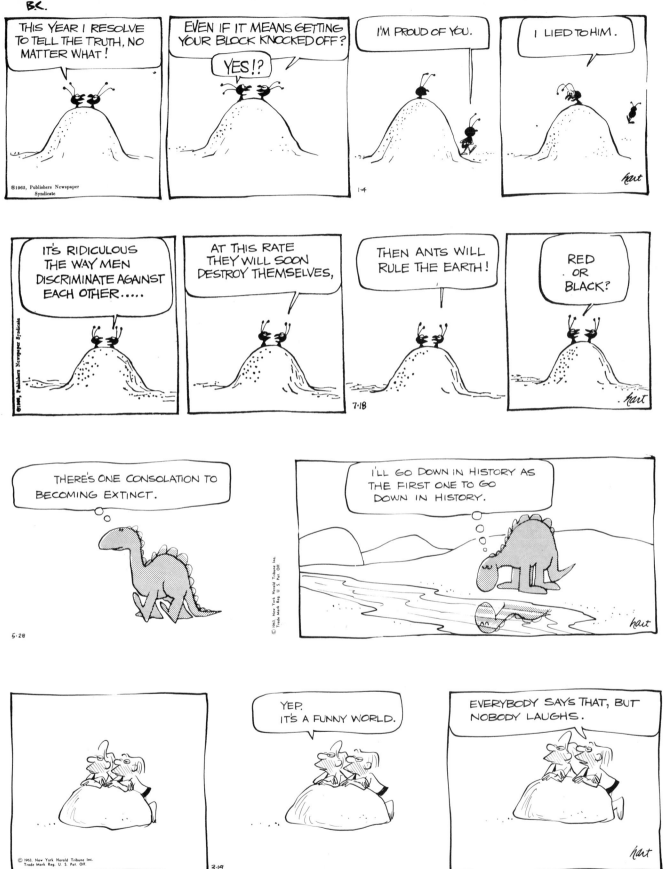

(Left) A rough watercolor sketch used as a color guide for a promotional work.

The Wizard of Id *cast of zany characters.*

A typical Sunday page directly after it has been inked.

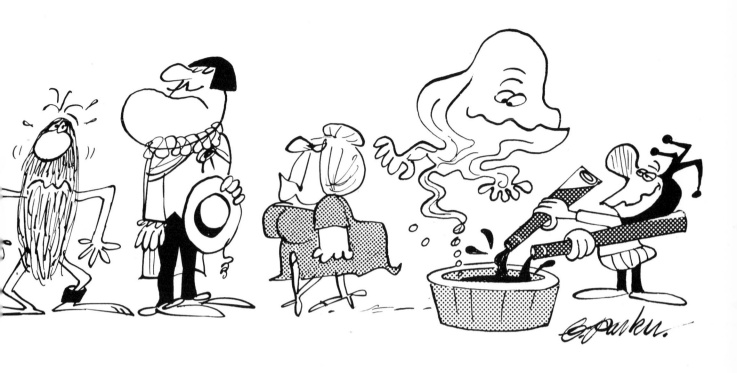

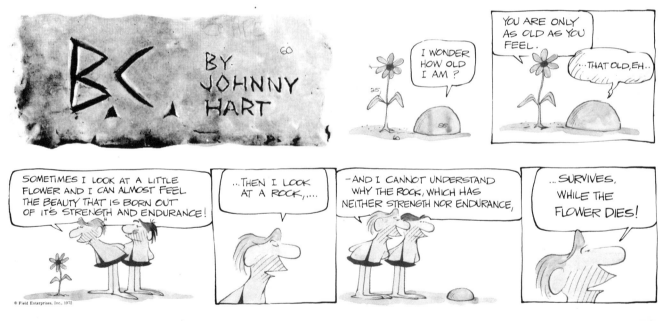

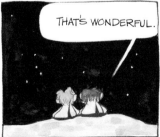

A photostat of this same page after it has been hand-colored as a guide for the printer who lays in the appropriate colors mechanically.

THE BREATH-TAKING "HUNG BY THE NECK" TRICK

Tell your audience that you have learned muscle control to such a degree you can survive being hanged for an hour without ill effect. You then mount a scaffold and are hanged in the standard procedure. To heighten the dramatic impact, scream, choke, gurgle, roll your eyes and generally make the hideous and disgusting noises associated with a hanging. After dangling limply for awhile, abruptly flop your head to one side and pop out your tongue as if dead. Then, after the fainters and retchers in your audience have been revived and cleaned up, suddenly spring to life as good as new!

HOW THE TRICK IS DONE

You will need a twelve inch length of steel pipe for this trick. After a little practice, you will learn to swallow it with the ease of a sword-swallower. Thus, when the noose tightens around your neck, your windpipe will not close completely and you can go on breathing. All that choking, gurgling, and disgusting noisemaking is just an act.

Proof once again that the best tricks are the simple tricks!

THE FORCEFUL "BRINGING A ROPE TO LIFE" TRICK

Take a length of rope out of your pocket and place it on the table. Then tell your audience that with two taps of your magic wand you can bring the rope to life, which you proceed to do to the unbridled rapture of acclaim of your viewers.

HOW THE TRICK IS DONE

To begin with, the rope is no ordinary rope. It is a braided piece in which one of the braids has been removed and replaced by a yellow snake of the right length. At each end of the "rope", a tiny thumbtack is concealed. Thus, when you bring the rope out and place it on the table, you are actually pushing down the thumbtacks. Then, when you give the two taps of your magic wand, you are actually knocking each end of the "rope" free from the table, and the snake/rope will slither away.

You might practice first with a string and a worm until you are truly proficient at this convulsing hoax on the people.

THUMBTACK · THUMBTACK

CONCEALED THUMBTACK · CONCEALED THUMBTACK

Two pages of "tricks" from The Mad Book of Magic and Other Dirty Tricks, *a paperback written and illustrated by Al Jaffee.*

Allan Jaffee

The Artist/Writer

"Being visually oriented, I never thought of myself as a writer," recalls Allan Jaffee. "I had no goals or ambitions in the writing area; I just traveled what I considered the normal route for an aspiring young cartoonist. I loved making funny pictures. And what's a funny picture if not a reflection of life, an image with a humorous slant? There were no words in those early attempts; only actions and situations. They either worked or they didn't. The ones that did became samples of *artwork*, nothing else. But when prospective clients laughed and asked "Who wrote the gag?" (which was very confusing since I didn't realize that any writing had taken place. I mean, writers used typewriters, smoked pipes, wore scarves—right?) my response was "I did, sir." When enough of them said, "Oh, then you're a *writer*, too," I took their word for it. Who was I to argue with prospective employers?"

So began the artist/writer career of Allan Jaffee. Fortunately, nobody told him he was a writer until he already was one, or he might have been too intimidated to have accepted the fact. Fear of the written word can be a debilitating handicap, especially difficult to overcome for someone brought up on foreign soil, as was Jafee. He was twelve when his family returned to the United States, fleeing an imminent Nazi takeover of the small Lithuanian town they'd lived in for about six years. Jaffee quickly learned that his natural ability for creating humorous pictures helped gain acceptance from the neighborhood youth. The sidewalks and walls became a gallery for the fledgling cartoonist as he produced Popeye, Dick Tracy, and other cartoon favorites for his delighted companions.

As a teenager, he was able to speak English without the slightest foreign accent. But, even more important, he drew well enough to be accepted in the newly established High School of Music and Art in New York. Jaffee's was the first graduating class of this specialized, highly regarded school. Some of his teachers submitted his work to The Art Students League, and Jaffee was offered a scholarship to continue his art studies there. But those were troubled times. The economic picture wasn't too bright, and war with Germany seemed inevitable. While reluctant to give up the scholarship, Jaffee felt he might benefit more by professional cartooning. He began by creating *Inferior Man*, one of the earliest of the costumed superhero satires and drew the feature for one of Will Eisner's comic publications; Eisner, a well-respected cartoonist, was creator of the famed "Spirit" character.

When World War II started, Jaffee enlisted in the Air Force, serving for three-and-a-half years. His professional cartooning experience proved very helpful when he was assigned to the Air Surgeon's office to prepare training aids and booklets as well as do illustrations for the convalescent rehabilitation program.

Emphasis on communication

"Whether drawing or writing," says Jaffee, "the prime factor to me is communication. Details and technique are important, but only *after* the direct line of communication has been firmly established. Just a few lines—whether drawn or written—are often enough to create the impact one strives for. If 'brevity is the soul of wit,' it follows that overstatement can be the death of it."

Brevity, however, is often just what the client is *not* buying. An unfortunate attitude prevails among many buyers of humorous illustrations who consider cartoons somewhat beneath other types of art. This buyer finds it difficult to evaluate a humorous drawing made with a few pen strokes against, say, a fully rendered tempera illustration. The fact that the simple drawing carries the message while the fancy one does not (or perhaps does, but not as well) seems to elude him. This "getting your money's worth" syndrome has created the demand for "a little more," which usually results in overworking, cluttering, and robbing a piece of its effectiveness.

Jaffee adds, "Ink and paper by the pound is the worst yardstick for measuring creative value. I've seen many assignments, by other artists as well as my own, made less effective by the demand to fill space and render to death an idea whose basic charm was its simplicity. It's generally not the fault of art directors. They're aware of the problems and solutions available, but must bow to a hierarchy of non-artists who have final say (they issue the checks), which creates and perpetuates these frustrating and fruitless practices."

Humor, parody, and satire

Humor makes its own point: it's a complete entity, its purpose to entertain; it stands (or falls) on its own. *Satire*, on the other hand, carries an underlying message. Under the guise of humor, it makes a totally different point, usually in the realm of criticism. Its purpose is to educate through entertainment. Somewhere between the two lies *parody*, which depends upon prior knowledge. Parody utilizes the familiar in such a way that we recognize both the original and the departure from the original. Its purpose is to entertain, to educate, or both.

Jaffee continues to work in all three veins, but speaking only as an artist, finds parody the most technically broadening. "In attempting to capture the look and flavor of the original," he says, "I start off by trying to employ its medium, and, in so doing, I've learned how to handle a wide variety of techniques. If the original has a photographic quality, I naturally forgo my usual line emphasis and work in any media that will produce the three-dimensional effect I want. I don't work for a 100% copy. My objective is to create illusion, not duplicate an original. It's the injection of opinions, feelings, and interpretations that makes the difference between a creative artist and a skilled renderer. If I'm parodying a well-known piece of artwork, I bear in mind not what the *original* looks like, but rather what it *has* looked like to most of us who have only seen it on a printed page. An original piece of advertising art is a good example. With the exception of those involved with the ad and its production, the original art is rarely seen. But millions of people see its reproduction in publications.

"If I can get the right feel by using, let us say, acrylics, although the original was executed in oil or watercolor, then that's what I'll end up doing. *Anything that will help me create the credible phony!*"

Satire allows the artist considerably more freedom. It makes no demands technically nor does it necessitate the use of certain media beyond the limits of its eventual reproduction. This freedom was meant to be enjoyed. Whether directly to the point, allegorical, impish, impudent, or outrageous, the drawing approach should be as imaginative and free-wheeling as the text or dialogue it illustrates.

Jaffee utilizes this freedom to the utmost, distorting the figure, exaggerating the facial features and expressions, or creating outlandish inventions to combat today's social ills. In these, the mood or feeling about the work determines the media employed.

Inherent freedom

I believe the greatest difference between the humorous illustrator and the "straight" illustrator, aside from the obvious difference in objectives, is the kind of thinking that must precede their work. The "straight" illustrator must deal in facts and details relying on mood, atmosphere, design factors, and compositional elements to achieve his effect. He's restricted by actuality. For instance, there's one way to draw a foot correctly—and that is *correctly!* Five toes, an ankle, a heel, an arch—and all in the right places. The cartoonist, on the other hand, is not bound by any of these rules; exaggeration and distortion are part and parcel of his trade.

"I feel restrained when asked to work more repre-

A children's book illustration executed in ink line and pastel.

sentationally," says Jaffee. "My flights of creativity are curtailed by involvement with what I know rather than what I can originate. Perhaps the quality that attracted me most to humorous illustration is its inherent freedom. The cartoonist's limitations are dictated only by his market (what's cute to one editor may be grotesque to another), and sometimes by his own success. As paradoxical as that may sound, a successful style or technique can limit both your freedom and your growth if your market demands that you follow a proven style. 'Give me the same kind of treatment you did for *Birdbath Magazine*,' is, unfortunately, a philosophy shared by many editors and art directors. I've often had to convince someone by the most dreaded means at a free-lancer's disposal—speculation—that a new technique or approach can be just as, if not more, effective than the old, especially when it's custom-tailored especially for the job at hand."

It's very difficult for the student to understand this, but the point must be emphasized to those just starting out. By all means, work for your own unique style. You need it to set your efforts apart from others when seeking work, but don't lock yourself into it. As trends and interests change, the hottest artist can cool off all too quickly. You must have a reservoir of different visual and graphic approaches to back you up during a drought.

One of the most difficult problems a cartoonist encounters is when and where to depart from his training and background as a representational artist. It's a contradictory process, the pull and tug playing a large part in the artist's approach and development. Like many others, Jaffee was intimidated by the tradi-

tional phases of his art education: he enjoyed learning anatomy and perspective and sacrificed all for accuracy. "Totally lifeless work," he recalls. "I later found that the further away I went from accuracy, the closer I got to atmosphere and mood. I had no new story to tell when confined to reality. Besides, there were so many others who could do it better. With *funny* pictures I could be more subjective. Uniqueness and individuality are the result of a personal approach to art. They can't be learned or taught. Needless to say, I fared better with no restrictions."

The act of drawing

"I find the act of drawing stimulating and pleasureable," observes Jaffee. "Like many others, I'm affected by writer's reluctance, artist's inertia, and anything else you want to call the stalling, pencil sharpening, coffee brewing, TV watching, etc., etc., that takes place before I finally sit down to work. Panic sets in as mounting deadline pressures and impatient editors' calls take effect: at last, hand touches pencil. Once started, however, I'm always amazed at how much I enjoy working, and I'm completely baffled by the lethargy that kept me from plunging in. Even little things, such as the sound of the pen scratching the paper or an accidental spot of ink that works, are satisfying to me.

"I express myself best in line and use it as the foundation for most of my work, color work included. I generally use transparent media, utilizing the full color range available in watercolors, dyes, and pastels. Magic Markers and/or lampblack washes are

America adjusts to Benson & Hedges 100's.

In this popular ad campaign, Jaffee's gag roughs captured the spirit the agency was looking for and were used as is, without ever having to go to "finishes." Courtesy Benson & Hedges.

very effective for black and white tonal work.

"For three-dimensional effects I've worked in acrylics, using anywhere from 10% to 90% of it in relation to Designer's colors. At first, it was difficult to harness the numerous effects that can be achieved with that medium; once a reasonable amount of control was established, I found acrylics irreplaceable. From subtle to vibrant, from thin and transparent to thick and opaque, from watercolor to oil effect—just about anything one asks for can be squeezed out of a tube of acrylics." It is understandable why Jaffee sings the praises of this recent medium. Parody relies upon a frame of reference to be truly effective, so Jaffee's rendition of the product must be a reasonable presentation of the original *despite* his humorous additions, deletions, and distortions. He's called upon to paint jet planes, housing developments, intricately carved decanter bottles, complicated electronic equipment—just about everything imaginable. And the object is the fake-out. The viewer's first impression, even if it lasts a split second, must be that he's looking at the original. By the time he realizes he's being had, it's too late to cancel his surprised double-take and subsequent laugh. And that, after all, is what it's all about.

Working with blue pencil

When asked to show roughs or preparatory sketches, Jaffee works with light blue non-reproducible pencil so he can ink directly without having to erase. The platemaker's camera doesn't pick up the blue (unless desired, in which case a special filter is employed), allowing only the black to come through in reproduction. Besides saving the artist time, the blue pencil method prevents paper surface damage that frequent erasures can create. It also insures against possible loss of intensity after a line has been worked over in an attempt to erase underlying pencil work. Jaffee also finds this method less intimidating: with no definition he's free to explore other possibilities, whereas with black penciling he's thinking more of eventual reproduction and how a line will look. His pencil work then becomes a commitment, something to be followed carefully, in contrast to the blue penciling, which seems more ephemeral, the images cloud-like. This allows for a free, uninhibited inking that's selective and pertinent to the total outcome, not just cold, dull stage making a pencil line suitable for reproduction. "Color work is a different story," continues Jaffee. "The greasy base of the blue pencil creates many technical problems not found with the ordinary 2H pencil."

Jaffee uses several varieties of pens, his choice depending upon how and where the drawing will be reproduced. When the line work will stand alone (or perhaps with light washes or marker gray tones), he prefers a hard, inflexible "school nib" with standard holder for its broad, definite line.

Of the fillable or cartridge type of drawing pen, Jaffee finds the Pelikan 120 to be the most reliable, especially when used with F-W India ink. This pen provides a strong, flexible point that allows for a thick and thin effect as well as variable widths for cross-hatching and other techniques. Jaffee can thereby carry his work around with him with a minimal amount of studio equipment.

Illustrating the work of others

"I don't think that I'm so good an artist that I can mindlessly decorate someone else's writing," admits Jaffee. "Illustrating the work of another might seem an easier task at the outset—after all, you're only responsible for the *graphic* end —but actually it's more difficult for just that reason."

In such cases the artist is forced to think differently, try approaches he might never have attempted otherwise, only because the visualization problems were not being solved *as* the work was being created. The old reliables, the successful and proven methods and approaches, are not locked into the writing material as it usually is when the artist himself is the writer. His job now is to marry his artwork with someone else's point of view, projecting himself into the visualization concepts of another who might not think visually or express himself graphically.

"In some ways this may offer a greater opportunity to grow as an artist," suggests Jaffee. "The challenge present in illustrating the writings of others can be useful in developing answers to problems in your own work. When the shoe is on the other foot, I find it both amusing and educational to study the work of other artists who have illustrated *my* text. It's a delight to see what a Coker or a Davis will do with my ideas, and, in a great many instances, it helps broaden and improve my approaches."

Helpful though it may be, Jaffee is, of course, happiest when he's illustrating his own text. There are no two separate stages—Jaffee the writer can work his ideas towards what he knows Jaffee the artist can do. He is in command. His writing is inherently geared away from the word, therefore emphasizing rather than limiting the graphic potential. He doesn't have to check out the author's intent with the author or editor, and there are no long, sometimes unpleasant, discussions of interpretation. This freedom shows in the work which is that much better for it.

Al Jaffee is a funny man. Unlike many humorists who reserve their talent for the printed page, Jaffee is an entertaining in person as on paper. He's neither cynical nor overly caustic, nor does he use his wit as a rapier. He's simply a rascal whose impishness delights a vast following.

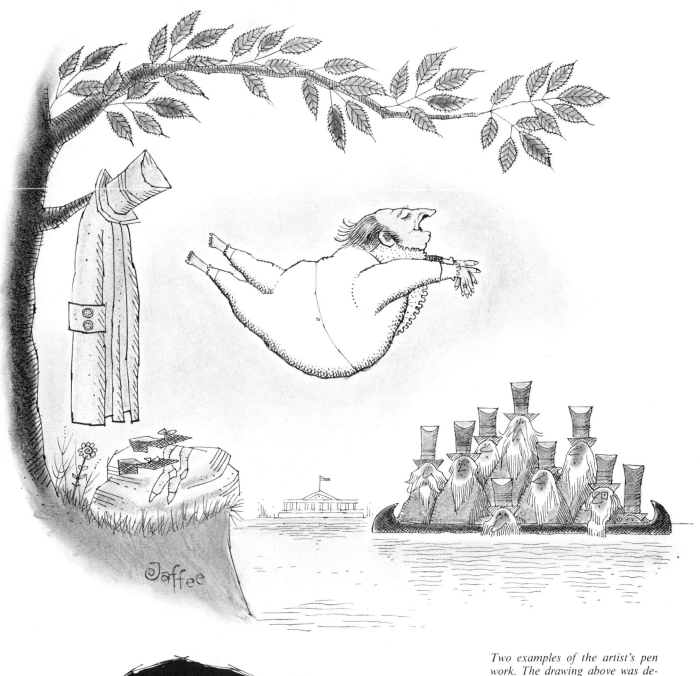

Two examples of the artist's pen work. The drawing above was designed for the pastel coloring that followed. The drawing to the left was done with a black and white treatment; the flat black served both as color in the sky and shadow on the near side of the grave markings.

(Left) Jaffee utilized a full range of tubed gray watercolors to achieve the full, tonal rendering in this drawing designed for black and white halftone reproduction.

(Above) Pen and ink were used to create the children's book feeling for this "medical Mother Goose" satire written by Larry Siegel. Reproduced by special permission of Mad Magazine *(© 1970 by E.C. Publications, Inc.).*

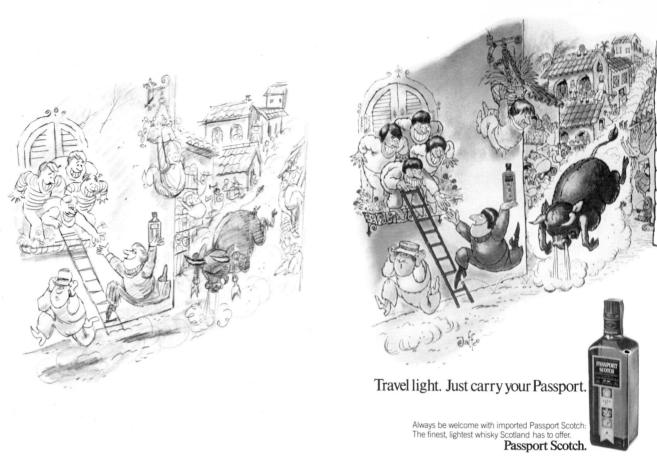

Rough (left) and finish (right) for one of the series of ads Jaffee created for the Passport campaign.

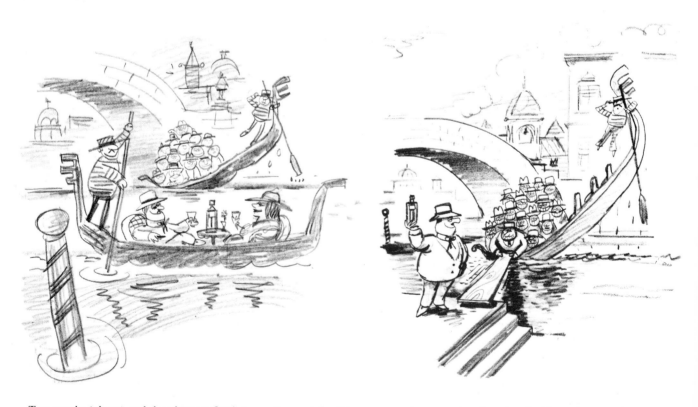

Two roughs (above) and the ultimate finish (opposite page) for this same popular campaign. Reprinted with permission of Calvert Distillers.

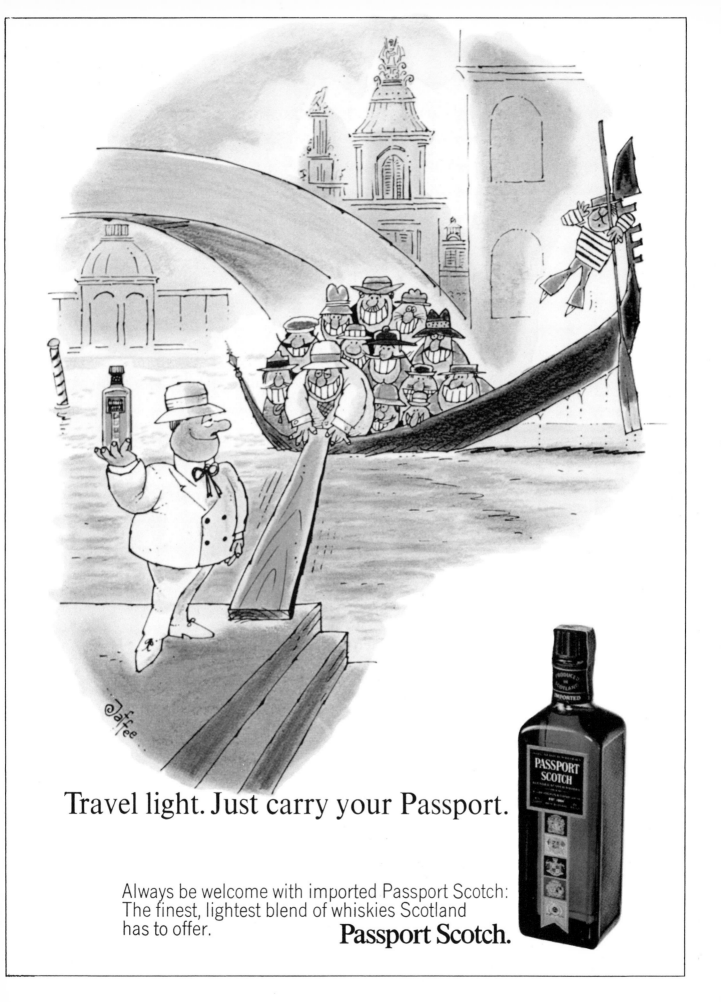

Travel light. Just carry your Passport.

Always be welcome with imported Passport Scotch:
The finest, lightest blend of whiskies Scotland
has to offer.

Passport Scotch.

The pencil, ink, and final stages (with two tones of gray overlay) of a "crime-stopping" sequence written and illustrated for Mad. *Reprinted by special permission of* Mad Magazine *(© 1973 by E.C. Publications, Inc.).*

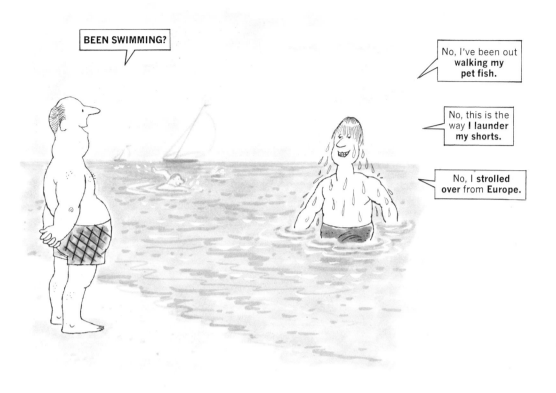

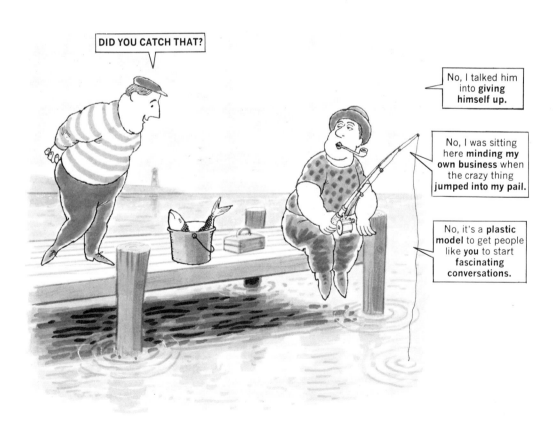

Both Mad's Al Jaffee Spews Out Snappy Answers to Stupid Questions *and its sequel,* Mad's Al Jaffee Spews Out MORE Snappy Answers to Stupid Questions *have proven to be among the most successful of the series of* Mad's *original paperbacks. The artist has found that a strong ink line and gray markers reproduces well on the grainy, highly absorbent paper used in paperbacks.*

Bob Jones

Animal Whimsey

"Animals don't try to be cute, charming, endearing, entertaining, or any of the human qualities we attach to them," states Bob Jones. "Because they live instinctively and impulsively, their "cuteness" can only be caught by chance, Either on film or by the efforts of a very tenacious photographer. He must be willing to endure the arduous task of waiting for hours to capture that moment when the animal performs an action or has an expression that provokes an "isn't that just darling" kind of response in us. What a humorous animal artist must do is *create* the action, expression, attitude, or whatever, that will elicit that same response."

Humorous animal illustration is achieved by more than just exaggeration. In effect, many of the same principles that go into caricature are evident here. But it's the *humanization*, the projection of "people" traits into animals, that enables the ad, greeting card, illustration, children's picture book, and animated cartoon to succeed.

Jones was born in Hollywood, California. Warner Brothers Studio was not far from his home. By age fifteen, he was working part-time in their animation division (the quality of his samples notwithstanding). Until that time he had been greatly influenced by Walt Disney, whom he still regards as "the finest example of taste, talent, and wholesomeness the United States has ever had." His stint in an animation house whose approach differed from Disney's helped Jones expand his style and range. Most of the artist's work was on *Bugs Bunny* cartoon features. For over two years he served on the lowest rung in the animation hierarchy as "in-between" man. The in-between man's job is to pencil the action for sequences between the key or major animation cels. Had Jones continued in this area, his next job would have been as "clean-up" man. Clean-up is the tightening stage that insure crisp outlines and fluid motion, prior to inking by the painting department. The inking itself is done on acetate with a special black ink designed for this surface. The color is then applied to the *back* surface of the acetate. This is to allow the line to stand without the color covering or weakening it, much like a coloring book process in reverse. "Breakdown" man is the next step after clean-up. The responsibility here is for the rough sketches (or *visuals*) that are created from the written script. Over this

level exists the assistant animators who do the key cels. At the top are the head animators who actually create characters and design the production. But before Jones could embark on this upward climb he had to face a different chain of command—in the service!

When Jones entered the Navy at eighteen he created a strip for the station newspaper. Called "Jackson Wolf, Esq.," it featured a wolf in sailor's clothing. With typical gob humor the emphasis was naturally on chasing girls. After the Navy, Jones attended the University of Southern California as an art major, learning figure drawing and fine art fundamentals. Though he considered these important, he felt he wasn't getting enough training for commercial art, his professional goal. Jones therefore transferred to the Art Center School in Los Angeles.

Training ground

Jones speaks very positively about the Art Center School. "Everything fell into place. I took commercial art and illustration courses that were very practical in their training methods and approaches. I remember sweating over the problems posed in three-point perspective. We also did a lot of drawing from photographs on the premise that if you work from photos you'll learn how modern illustration is done. The emphasis was unquestionably on the *commercial* rather than on the *art* of commercial art, but for the struggling novice it was a good way to gain experience in a quasi-professional atmosphere."

Among Jones' classmates were some of the top people in illustration today, including Jack Potter, Ben Wohlberg, and Bob Peak. After two-and-a-half years of study at the Center Jones was fortunate in meeting Willard Mullin, the popular sports cartoonist of the now defunct *New York World Telegram and Sun*. The meeting proved to be the turning point in Jones' professional life. Mullin encouraged the young artist to go to the East Coast. He felt the rapidly growing advertising field there offered more chances of employment for the beginner than anywhere else. With Mullin's help, Jones settled in the East.

Soon Jones began his long association with the Charles E. Cooper Studio, an advertising illustration organization. Once again, he was fortunate to work alongside some of the top names in illustration at the

time: Joe Bowler, Coby Whitmore, Bernard D'Andrea, Joe De Mers, Bob McCall, and his old schoolmate Ben Wohlberg. Jones learned much here as he was able to witness the start-to-finish production of illustrations and ads that would later appear in leading magazines.

Most of Jones' earlier assignments were humorous in nature (Charles Cooper responding favorably to Jones' light touch and feel for whimsy). The walls of the Cooper studio were lined with samples, sketches, recent assignments, or whatever other evidence the participating artists cared to display of their talents. One of Jones' first animal drawings hung with the rest of his realistic figure work and caught the eye of visiting *Saturday Evening Post* art director, Frank Kicker. On Cooper's recommendation, Jones was asked to try an assignment on speculation. If he delivered the kind of animal drawing The Post was looking for, it would be bought and used in a forthcoming issue. If they felt his work was not right for their article, they could turn it down without being financially obliged. This is the kind of situation artists should avoid like the plague (you can end up working on speculation forever without seeing a dime; the cards are all stacked in the buyer's favor—no risk, no effort, no money!). However, Jones was encouraged to try it by Cooper who told him to do it during the day on studio time. That way, he was still getting his regular salary. The risk thus transferred to his friend and employer, Jones proceeded to work out several complete illustrations depicting the required scene.

The young artist benefited from the advice and professional know-how of his encouraging studio buddies. "With that kind of support, how could I miss," concedes Jones. "*The Post* bought the one everyone agreed was best to submit. That led to four or five other animal jobs. I eventually got to do other subjects for them as well."

In the cards

In 1957 Jones worked up a full color illustration of a cute mouse with a hammer breaking a Christmas candy jar. He brought the design to the *Book-of-the-Month Club*. Besides their vast book-by-mail operation, this organization also produces its own line of Christmas greetings for sale to Club members. The Club purchased it. Since that time Jones has sold a new animal painting for this purpose each year developing a series. The second design depicted a mouse–dog situation, the third and fourth a mouse–cat, and finally, from the fifth design on, the mouse–cat–dog trio. This "family" of characters has proven to be a favorite with the Club members year after year.

The whimsical situations are always based upon the humanness of the animals. They never play up the typical "natural enemies" situations that have long since become clichés of themselves.

A tiger by the tail

The most far-reaching of Jones' animal work was done for Esso's "put a tiger in your tank" campaign. The posters, print ads, billboards, and animated commercials were part of one of the most successful advertising campaigns ever created for establishing product identity. So successful, in fact, that when Esso, Humble, etc. decided to consolidate their various regional brand names under one Exxon label, the tiger was taken "out of retirement." The company spent millions of dollars in a new national campaign. They utilized the eight-year-old tiger theme to let the populace know it was the same product with only a change in name.

Jones of course was the only artist called in for the lovable tiger's comeback. "It wasn't quite that way the first time around," the artist recalls. "Someone at

After Jones gets through with them, even the most feared animals and reptiles begin to look like lovable house pets.

McCann-Erickson had seen some of my newer animal drawings on the Cooper Studio walls (come to think of it, those walls got me a lot of work) and invited me to submit samples of tigers for a new campaign they were working on. I sketched a few and several days later went there to show them. I was ushered into this room filled—literally filled—floor to ceiling with tigers. It was bizarre. I guess everyone who ever drew an animal was called to submit samples. Some of them were really beautiful, but my stuff was a little different. When I think of tigers, or any member of the cat family for that matter, I *know* they're strong, sleek, lithe, fast, and everything everyone thinks about them. So why stress only *that* side of them? Instead, I tried to play up the "nice-guy tiger" aspect and worked for an easy-going, fun-loving, friendly sort of tiger. I guess that's what they were looking for—I got the assignment!"

Jones used photographic reference to design the tiger's markings, basic proportions, and other details. But once confident that his tigers were convincing as animal studies, he began taking license with the forms. Combining realistic with cartoon treatments, he produced a basically elaborated animation drawing.

Materials and techniques

Most of Jones' assignments are full color. He uses a variety of techniques and media in executing them.

The artist is equally comfortable with tempera, inks, or dyes. He will often begin an illustration with colored inks as underpainting. Jones then works his tempera over it. The color of the second stage reinforces the color already there. In some areas Jones allows the ink to remain, especially in the darker sections where their transparent quality works very effectively. He is more concerned (as a commercial artist should be) with the *reproduction* of his work than with its original appearance and works freely toward that end.

Jones prepares his color work by doing extensive pencil studies on a large tracing pad. He first concentrates on the compositional elements and advances to the other aspects of the design when the composition has been established to his satisfaction. He often employs a light box (a translucent glass set over a lamp in a metal or wooden cabinet or table which allows the light to pass through both sheets of paper so that the artist can trace the image directly from the first to the second). He traces only those areas worth employing and discarding those that don't work well for his overall concept.

When color sketches are required he will sometimes use a tracing vellum that has been treated to accept water-based paints, such as Luma watercolors (bottled liquid transparent colors), Pelikan inks, tempera, and/or acrylics. Jones tapes the vellum over his finished pencil drawing so that he can lay the colors on directly. The advantage of this method is that he's

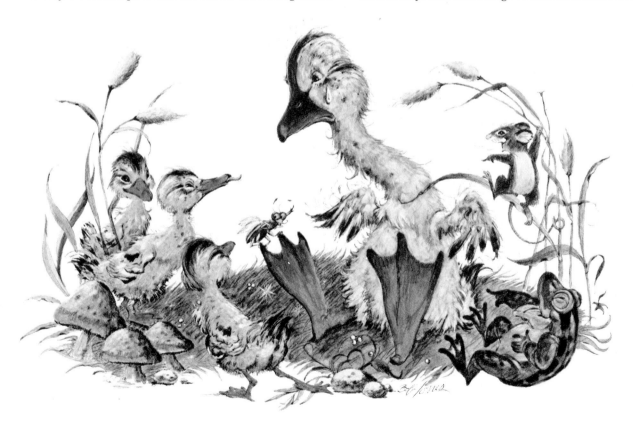

This "ugly duckling" illustration served as the cover for a children's record album of that name. Courtesy MGM Records.

able to produce as many color sketches as necessary without redrawing or destroying the pencil work.

Jones prefers the Anjax board for much of his finished work. For penciling, he uses #2 writing pencils, spraying afterward with workable fixative.

His penciling, even on illustrations that will eventually be covered with paint, is worked up to the same degree as pencil drawings that will be reproduced as such. "The more problems I solve in the pencil stage," the artist explains, "the freer I am to concentrate on the color when I'm ready. A bad drawing can never be solved with paint, so I try to solve drawing problems in the drawing stage and painting problems while painting. The last thing I do in the drawing stage is pick out the highlights with an eraser or help turn a form by erasing some of the penciling on the planes facing the light source. At this point I'm ready to start painting or laying on my ink washes.

"For pen work I find the crowquill point too hard and unyielding. The Gillott company has a flexible nib known as the "cartoonist's point" with which I've had a lot of success. On the other hand, I did a whole series of drawings for the *Pink Panther Flakes* breakfast cereal using only a Rapidograph pen which has a very mechanical, hard point. It was perfect for this project, but I normally prefer the flexibility in pen work which is impossible to achieve with most mechanical pens.

"I like to experiment with different materials and techniques, but I find gimmicks—like palette knife painting or an especially tricky pen line—unrewarding, both as an artist and as a viewer. I become too aware of *how* it's said rather than *what* is said, like a speech with a lot of impressive words in it that say nothing."

Humanizing animals

As stated earlier, humanization is the most important element in the humorous illustration of animals. By

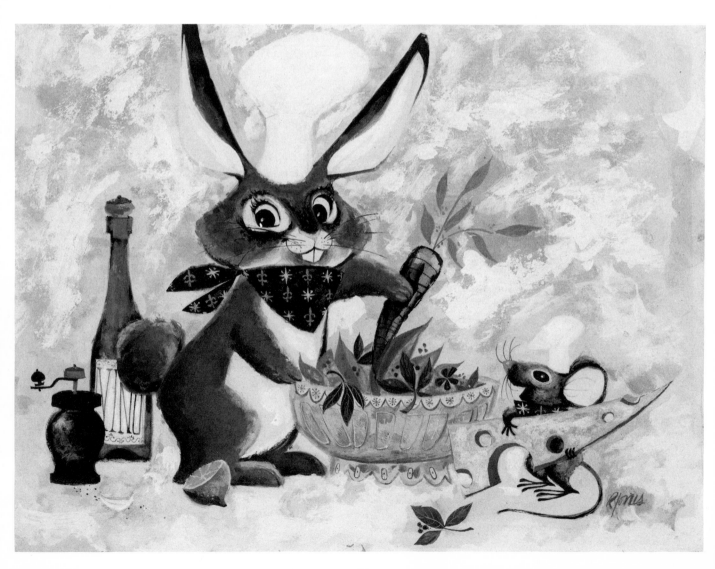

endowing them with typical human characteristics—those reminiscent of common physical types or stereotype personality traits—the animal begins to take on the attitude of a human without jolting the logical senses of the viewer or reader. Walt Disney was the master of this approach. From the time Mickey Mouse (nee Steamboat Willie) first appeared on a screen to the present, every animal illustrator owes Disney a measure of thanks. For Disney took his discovery, perfected it, and created an acceptable and successful art form.

Jones achieves his humanization through distortion and exaggeration of the animals' physical properties, fitting them to the human attitudes he's trying to portray. He starts by drawing the animal (in most cases in an upright position), re-creating the arms and legs in recognizable animal forms. While incorporating human gestures, he's careful that the distortions are not unbelievable or grotesque. Because of the subtle transitional qualities involved, Jones redraws the forms constantly, the light box playing an important role once again.

Facial features must undergo the same concentration and effort. "The smiling animal is easiest," offers Jones. "Many animals, like cats, hippos, and alligators, have upturned mouths to begin with. They already look like they're smiling. It's getting them to *frown* and smile at the same time—which I had to do with some Exxon tiger situations—that makes you reach for the aspirin."

Specialization

"I've been involved with all kinds of illustration all my life: serious, straight, and in between," explains Jones. "I never set animal drawing apart from the rest of my work. I feel that drawing is drawing, whatever the subject. I gave animal drawing my best—nothing more, nothing less. So in a way it's surprising that I've become a "specialist" in this area. The title, by the way, comes from others. Naturally I'm pleased at such favorable response to my animal work, but I'm still confused by the whole thing."

Jones does not consider himself an expert on animals or animal drawing, but the temptation to play Freud is very strong when you learn that his father is a retired veterinarian. No doubt the proximity to animals and the awareness produced in a situation of this kind have impressed the budding artist's sensibilities. At any rate, Jones' "natural" feel for the subject has helped him create some of the most appealing animal art of its kind today.

Bob Jones doesn't consider himself a specialist. He simply draws and paints animals as "human" as he can, while still keeping them in their own world. His approach has proven very successful: when someone needs an animal drawing, he's one of the first artists called—not a bad position to be in, specialist or not!

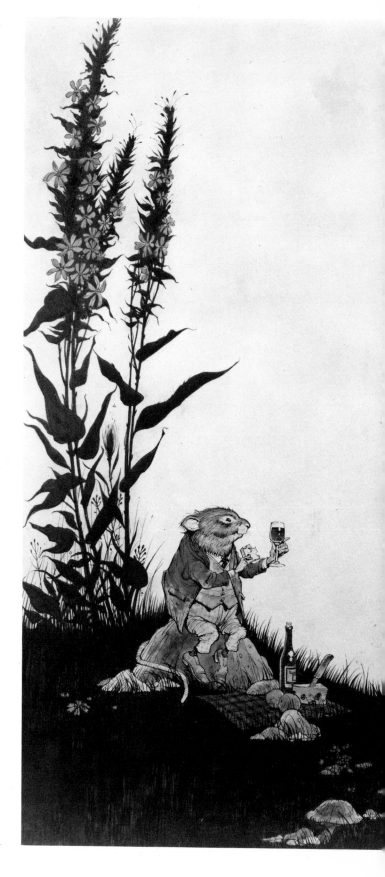

Obviously, there's no similarity between Jones' Picnic On The Grass and Manet's except in title. This work was rendered in ink line and liquid Luma watercolor washes.

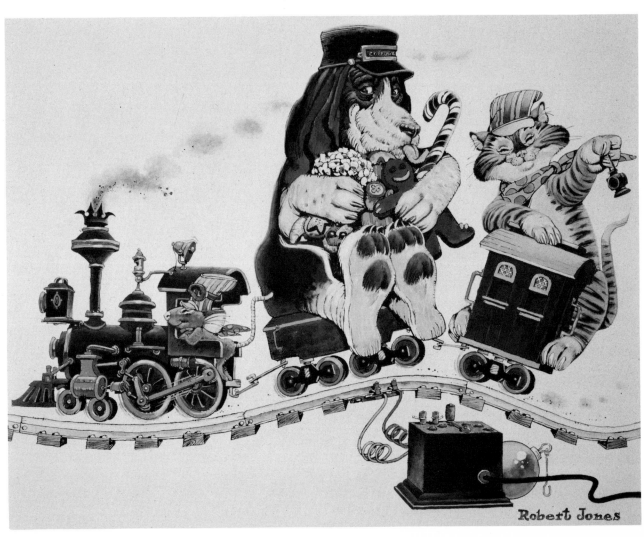

Color rough (left) and final rendition (below) for the Book-of-the-Month Club's Christmas greeting.

(Opposite Page) Two other examples of this popular series Jones began in 1957. He has designed a new one every year since.

Robert Jones

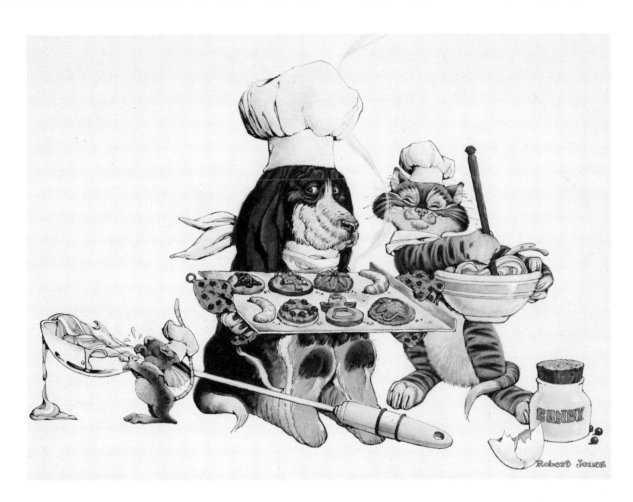

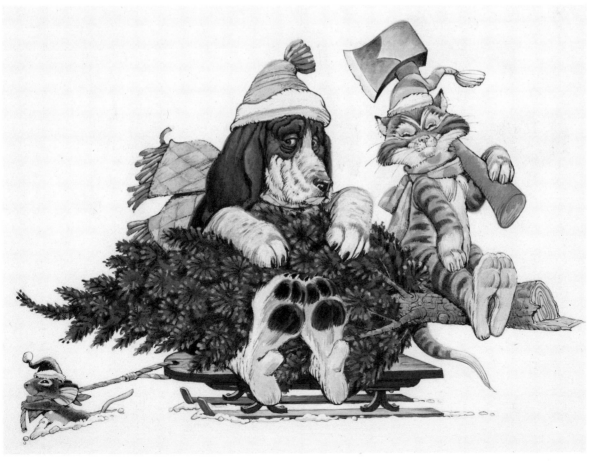

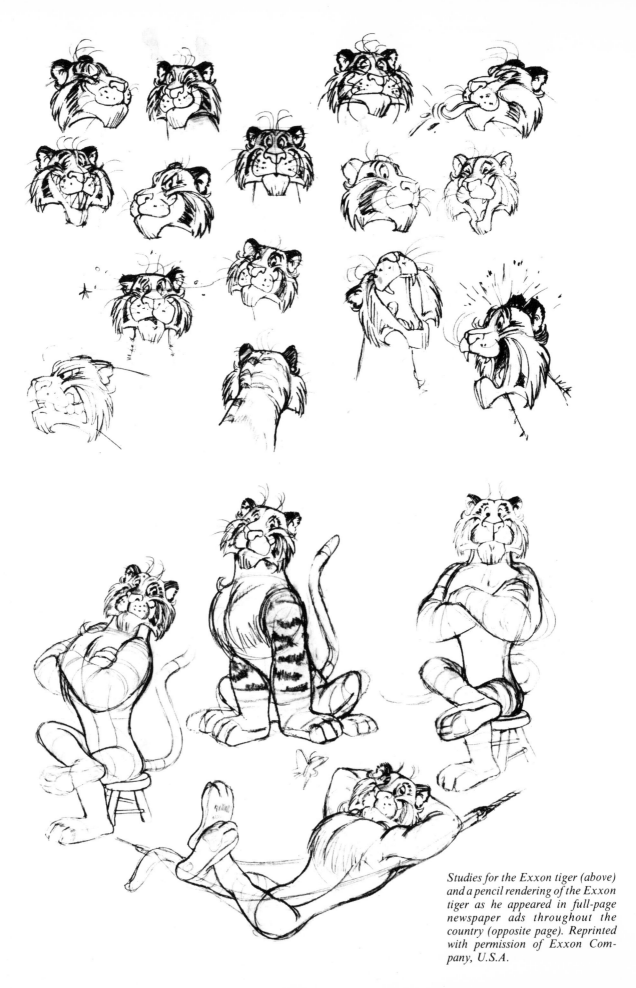

Studies for the Exxon tiger (above) and a pencil rendering of the Exxon tiger as he appeared in full-page newspaper ads throughout the country (opposite page). Reprinted with permission of Exxon Company, U.S.A.

"If she says 'Yummy,' it's bonuses right down the line."

Donald Reilly

The Gag Cartoonist

"I don't know how one studies to become a gag cartoonist," states Donald Reilly. "A natural cartoon differs from a contrived one in that the funny comment or situation and the graphic expression of it fit very well. They fit because the artist also wrote the idea. This can be learned, I think, but not taught."

The essence of the so-called "gag" cartoon is its simplicity and directness. If successful, it communicates instantly, producing an immediate reaction. The drawing should do everything to strengthen and speed this reaction. The idea is the thing, and the drawing must put it across quickly and effectively. The faster the thought is communicated, the greater its impact. The cartoon is, by definition, a humorous illustration; but it is only one example of that genre of art—it has little in common with a Norman Rockwell humorous illustration. Generally speaking, the cartoon does not intend to evoke the same kind of reaction. Readership studies prove that all magazine readers love cartoons, but it's the rare buff who spends time studying the drawing after he "gets" the idea. Conversely, readers may linger over a Norman Rockwell *Saturday Evening Post* cover, because of the various emotions evoked.

For all these reasons, a good gag cartoon drawing is not overdone: it's not executed in oils and it's not overly rendered, for that's the kind of thing that tends to stifle spontaneous humor. Nonetheless, the cartoonist may discard twenty or thirty versions of what are intended to be simple, funny drawings. Cartoons calling for more elaborate renderings are often easier to do, being more involved with the scope of the idea and detail of the drawing (two apt and funny people can be harder to draw than an ancient army laying siege to a medieval stronghold).

All of this has to do with the *appropriate* bridge from idea to final drawing. An overweight drawing can kill—or at the very least slow and dull—the impact of a sound idea.

Early influences

"I started drawing around the age of five or six," recalls Reilly, "after seeing the animated film *Gulliver's Travels.* I spent months drawing scenes from that picture, especially versions of the Lilliputians tying down the sleeping Gulliver by criss-crossing his body with miles of rope.

"Movies inspired my drawing for some years. My Frankenstein monster phase was one of my most prolific: I used my first bottle of India ink drawing Frankenstein's monster and was amazed as the drawing seemed to pop from the paper. I also copied comic book people like Captain Marvel, Batman, and the Blue Beetle, and invented strips of my own (action scenes were stressed because lettering the talk balloons took longer than drawing)."

In elementary school, Reilly discovered that drawing resulted in more than self-amusement: artists were a privileged group. While other kids had to rehearse for the dramatic pageant, the artists were encouraged to paint a twenty-foot paper mural depicting "early colonial life" for display on Parent's Night.

A few years later, *Life Magazine* ran a "Lena the Hyena" contest, based on the comic strip *Li'l Abner.* The idea of the competition was to draw a creature revolting enough to be considered for actual use as a character. Reilly's submission didn't win (the victor was Basil Wolferton), but, as Reilly recalls, "My sister said my drawing made her want to throw up. I realized then that I had a unique ability to reach people with my art!"

The Jazz Era

When he entered high school, Reilly abandoned drawing almost totally in favor of practicing the trumpet by day and listening to radio broadcasts of dance bands and jazz groups by night.

At Muhlenberg College Reilly studied neither music nor art, but majored in English literature because he enjoyed writing. He also took as many hours of sociology, political science, and psychology as he could. Undoubtedly, these are the areas of study which helped form and broaden his view of contemporary life, enabling him to approach the *thinking* stage of his later cartoon work with perception, intelligence, sophistication, and wit.

Reilly found no conflicts in his milti-faceted existence: he was an editor of the college newspaper, wrote a column, drew his first "magazine-type" cartoons (and published them on the pages he edited),

and played in jazz groups on weekends. He considered putting all his energy into a career in jazz, but one evening of listening to Dizzy Gillespie did a lot to change that notion. He explains, "Gillespie is not to be believed. His phenomenal work helped me to see my own talent in the proper perspective and to realize that I would never be more than an 'average-to-good' jazz trumpeter."

Fortunately, he was not discouraged when his first attempt to crack the professional cartoon market failed: during his junior year he had mailed five or six drawings to *The New Yorker*; they were returned with the customary rejection slip. By then Reilly decided his goal would be *The New Yorker*—about ten years later, he reached it.

Getting ideas

A question frequently asked of people in the communicative arts is "Where do you get your ideas?" The question seems naïve to the point of annoyance after the first hundred times. We've grown so accustomed to having ideas at our disposal, like water from the tap, that we often take this miracle for granted. And from so gifted a person the answer "I don't know, they just come" is disappointing and perhaps as naïve as the question. The real answer, "From life," would probably be equally disappointing to the inquirer, but at least it implies the actual process. The humorist, after all, depends upon a frame of reference. He doesn't create a situation, he responds to

one. He's reflecting an idea in a humorous way.

The gag cartoonist is faced with greater restrictions. However broad or pertinent the idea, he has but one scene and one or two lines in which to tell his entire story. "My working procedure is simple enough," reveals Reilly. "I start off each day by reading *The New York Times*. I don't use writers or gag files. My only research is what I read in newspapers, magazines, and books, or pick up from radio and television. It's all there—the thoughts, the trends, the fads, the styles, the words of contemporary America—these serve as a basis for almost all my cartoon work."

It's this humorous response to everyday living that viewers react to. The gag cartoonist's *observations* are, in many ways, no different from their own. It is the artist's attitude that makes the difference. In Reilly's case, an innate skepticism enables him to see these same details in a ludicrous light and portray them in a universally humorous way. "I was one of those kids who always felt like bursting out with laughter in class or church. I guess I never outgrew the habit and still respond this way to the pretentious and contrived attitudes often demanded of us."

Reilly doesn't wait for inspiration, but prefers to meet the problem head-on. As he reads his daily newspapers and current periodicals, he takes notes, writing fragments of ideas or just words that might trigger other thoughts later on. He doesn't stop to finish or polish an idea during this stage of his work, secure in the knowledge that his intuition has proven

"GOOD GOD, MAN, CAN'T WE DROP THE BUSING ISSUE?".

The rough version of a Reilly cartoon idea as submitted to The New Yorker *for approval.*

fruitful in the past. Reilly is particularly interested in language. "Words seem to emerge anew as people use them," he observes. "With a new president, for instance, certain words or phrases become part of the everyday vernacular. Born of political administrations, they generally fade out of common usage during the succeeding administration. Business can have the same effect: we're now exposed to 'computer language.' It's remarkable how many people speak 'computerese' today."

The gag cartoon field

Magazine cartooning has always been a free-lance operation for all beginners and most seasoned pros. With rare exceptions (like *The New Yorker* which contracts a number of people to insure a steady flow of the highest quality work) the procedure remains basically the same for all concerned: you work up a batch of ideas, mail them to prospective clients (with careful records so that you don't repeat mailings), and/or make the "Wednesday morning rounds," that time set aside by most magazine humor editors to look over the week's submittals. Many professional artists prefer the latter procedure, finding it faster than waiting for the return mail. And besides, there is a social aspect to making rounds. Artists, meeting their cartoonist friends in transit at the same offices, may swap stories compare successes (and failures), perhaps gossip over lunch—a welcome change of pace from their work-at-home routine.

With the lion's share of advertising revenue going to television, the magazine field has deteriorated. *Colliers, Saturday Evening Post,* and *Look,* all at the top of the cartoon market in terms of payment and prestige, were finally forced to close. The demise of each was sudden. It had been known for some time that all were in trouble, but no one could really believe that these institutions would actually fold. The time lapse between each casualty was sufficient for most regulars to adjust somewhat. They altered their thinking, shifted their points of view, and hoped for a better day. Unfortunately it never came.

Magazine cartooning is a different field today, more precarious than ever. Many top names have left the business completely, utilizing their talents and reputations in advertising, children's books, and other related fields. Others took steady jobs as editors, writers, staff artists, etc., using their gag panel work for supplementary income. Competition increased as artists struggled to fill the needs of fewer existing buyers. Those with established reputations and followings did not enjoy much of an advantage in a business that supports ideas, not personalities.

The drawing

Reilly has great respect for the work of other cartoonists, but draws his inspiration from the fine artists. He isn't a student of cartooning nor does he save old cartoons or collect other cartoonists' work. He reveals:

"Good God, man, can't we drop the busing issue?"

The finish as it appeared in the magazine (© 1972 by The New Yorker Magazine. *Inc.*).

"I've always admired Peter Arno's cartoons for their strength and deliberation. However, my drawing in no way resembles his. I love Rouault's work for the black quality, his line, his strong and heavy color, and I love Picasso for everything! He has changed the way the world looks. All graphic art, sculpture, newspapers, ads, magazines. wallpaper—what *hasn't* been influenced by Picasso?"

Reilly's drawing is very relaxed in contrast to his first cartoons which were "tight and frequently overworked in an attempt to look 'professional'." An energetic and fluid, natural line and a feeling for composition in Reilly's work are the results of his fine art training. "I learned a lot at Cooper Union," says Reilly. "I didn't know what the hell I was doing when I applied for admission, but during five years spent working with excellent instructors (especially Sidney Delevante and John Kacere) I began to be able to see and draw. I'm dubious about 'cartoon' courses and the like. All drawing is *drawing*, and is learned by struggling in the studio the way artists have always done."

Roughs and finishes

"There's pleasure in thinking of an idea and doing a funny drawing," Reilly states. "By the end of a week I've usually logged about twenty-five ideas or fragments in my 'idea journal,' a simple composition pad I keep ready. Of these, only nine or ten get to the rough stage, and not all of these get submitted. I save unsold roughs because I often come up with a new concept for an old drawing. The pictures themselves suggest ideas other than those specifically written as the caption line."

Reilly generally begins a rough with charcoal pencil on 11″ x 14″ Navajo layout ledger bond, a 32-lb. paper that's strong enough to take pen work, wash, white-out, etc. He prefers this heavier-weight stock since tracing is never a factor. "If something goes wrong or I'm not getting what I want," Reilly explains, "I start a new drawing. I don't believe in trying to salvage 'the good parts' of a bad drawing as there are *no* good parts to a drawing that doesn't hold together."

A heavier stock also holds up better in reproduction, an important consideration since many of Reilly's roughs are bought and printed without finishes being requested. He may do six or seven starts before a finish satisfies him, and he finds he usually goes through a new pencil for each cartoon he produces. The second stage of a finish can be executed with whatever Reilly feels best suits the cartoon: charcoal, pen, brush, or all of these mixed together. He uses an Esterbrook steel school point or English Swan nib, bending them with pliers at times to offer a better or more comfortable angle to his direct, firm approach. Reilly prefers F-W India ink for the line,

"Wait a minute! How do I know you're not George Plimpton?"

Winsor & Newton ivory black gouache for the wash; he may also smear the charcoal with a wet cloth. His brush work is done with a Winsor & Newton #4 or #5 red sable watercolor brush. While drawing his cartoons Reilly always considers that his drawing will be part of a printed page, not an isolated feature. He looks at the work in progress through a reducing glass to visualize it reduced and surrounded by type.

For color work, the artist prefers the vivid hues he can achieve with Dr. Martin's dyes, supplementing them with tempera colors. He does his *New Yorker* covers in the exact size of the finished product, thereby confident that what he paints will be precisely what is printed.

Graphics and art

Labels and titles aren't applicable to those whose talents and personalities transcend standard convenient categorizations. While Reilly does, in fact, earn most of his living from his humor panels, he cannot be described as a typical gag cartoonist. His art is not of the "bubble nose, big foot" school of humor. He designs his cartoons in the same manner as his other artistic expressions, making numerous rough sketches, and often several finishes, before he's satisfied.

Reilly's professional schooling is indicative of the attitude this artist has toward his work. He studied drawing, painting, design, composition, color theory, art histroy, and whatever else was necessary to earn a degree in fine art from Cooper Union. He completed these studies at night over a five-year span while supporting a family by day, though the field neither requires nor expects such intensive preparation. This background, Reilly believed, would provide the draftsmanship and facilitate the expression he demands of himself. As a result, Reilly has created a market for his approach rather than let the market dictate the style. It has also resulted in Reilly's ability to broaden his horizons. His *New Yorker* covers are far removed from his cartoon work in both look and content (readers expecting humor may be surprised). They are graphic designs: powerful, exciting, sensitive, depending upon the subject. "I enjoy doing other graphic work," adds Reilly, "as a relief from having to be topical, clever, sociological, or whatever attitudes are requisite in my cartoons."

Reilly studied and worked hard to strengthen his graphic capabilities. He works for himself, accepting both favorable and unfavorable response to his efforts. From all this intensity and seriousness come the cartoons that have delighted millions on the pages of *Playboy, Post, Look, Saturday Review*, and, of course, *The New Yorker*. Not a contradiction, not a coincidence—merely the efforts of a dedicated graphic artist who can make people laugh.

"Believe me, if I had it all to do over again, you'd still be a frog!"

An example of Reilly's pen-only approach to a cartoon panel.

"If you don't mind, Perkins, just process the films without philosophizing aloud about the empty, dreary lives they record."

"It seems a tragic waste when you consider what Ralph Nader's intelligence and drive might have accomplished in some legitimate walk of life."

"Children with heated pools are no better than you are."

"He fails to amuse me. Have his writers executed." An example of the artist's earlier pen and charcoal technique for this full-page cartoon.

*"We've run out of virgins, O Mighty One! Will you accept a
photographer from the 'National Geographic'?"*

(Above) a cartoon drawing must hold up in terms of authenticity
and realism (despite the obvious simplification that must take
place) as well as a more serious attempt. Immediate recognition
of a situation is the key to a humorous response. (© 1971 by The
New Yorker Magazine, Inc.)

(Right) Reilly's ability as a graphic designer is evident in this
posterlike cover design. An exceptionally strong line was em-
ployed to separate the strong, flat color areas. (© 1971 by The
New Yorker Magazine, Inc.)

Nov. 13, 1971

Price 50 cents

THE
NEW YORKER

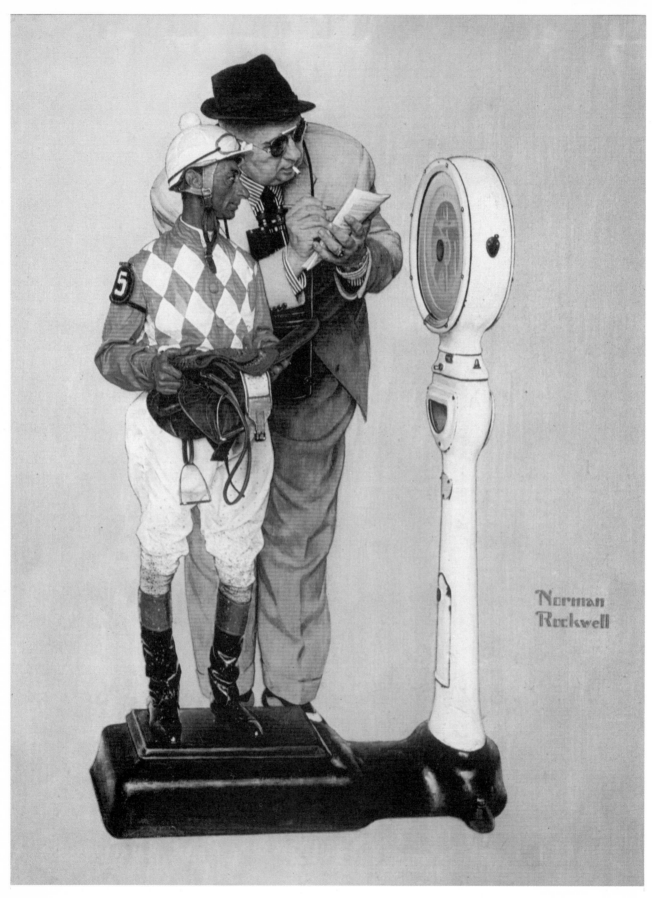

"Weighing In," reprinted with permission from The Saturday Evening Post *(© 1958 by* The Saturday Evening Post, *Indianapolis, Indiana).*

Norman Rockwell

Art as Entertainment

"I don't want to paint for the few who go to museums. I want my pictures to be seen and enjoyed by people who know little about art as well as the people who are experts on the subject. And the best way to accomplish this is to have them published," states Norman Rockwell.

There is insufficient space to bestow more accolades on Norman Rockwell. Anything I can say about this man and his impact on both American illustration and the American public has already been said. Rather than be redundant, let's concentrate on the humorous aspect of Rockwell's work, which, more than any other factor, sets him apart from all other artists.

Humor in art

Somewhere along the line humor in fine art has been dealt a deadly blow. Those who determine *taste* (perhaps the most enigmatic word in our language) have decided it's all right for an artist to move us to tears, change, revolt, and, in some cases, sleep—but to *laugh* is beneath the artist's station. Satirical work, like that of Daumier, can be excused; satire is an accepted vehicle for promoting serious thought. Humor for humor's sake, however, is considered lowbrow: hence, the lack of it on museum walls.

It's exactly this kind of thinking that prevents Norman Rockwell from enjoying a position closer to the top of the art hierarchy. Instead, he's crowned king of illustrators; more an act of appeasement, I believe, than anything else. The illustrator, you see, has made the unforgivable choice of painting commercially. But then, didn't the old masters? An illustrator, however, paints specifically for publication, not for painting per se—and so would Leonardo had he lived long enough to see a four-color press! The posters, book designs, music sheet decorations, and magazine illustrations of Toulouse-Lautrec don't seem to have influenced the prices his paintings demand on the auction block. The problem isn't semantics, as one might think, but sociological reluctance to pay ultimate tribute to someone in his lifetime: superlatives are saved for eulogies.

I'm not suggesting that Rockwell is the twentieth-century Rembrandt. That will be decided a hundred years from now. What I am suggesting is a reappraisal—if not a removal altogether—of the prevailing opinion that a humorous work cannot be taken seriously.

I'll never understand why laughter, a pleasant and positive experience, has been relegated to second-class status. More often than not, we honor "serious" film actors with Academy Awards, but wait decades to throw a bone to a Charlie Chaplin—and then under a "special award" category. This is hardly an isolated case: Laurel and Hardy, Buster Keaton, Harold Lloyd, and the Marx Brothers have felt the same stigma. While other entertainment media have sought to remedy this imbalance with comedy award categories, I'm afraid a Neil Simon will never be taken as seriously (despite his commercial success, and probably because of it) as a "serious" playwright whose play may close after three performances.

The importance of the idea

"The most important thing, assuming you're an artist already, is to get an idea," emphasizes Rockwell. "I try my ideas out on everyone I can induce to look at my sketch. I watch their reactions: only when people are enthusiastic do I become enthusiastic, too; never be afraid to discard an idea if it doesn't ring the bell.

"Artists should leave realism to the camera and create something from their imagination. I'll take maybe fifty photos for a scene I like. Then I'll pick the hands from one and the nose from another as guides, but they are only guides: the picture I make comes from me."

Rockwell commits his idea to paper in loose sketch form, allowing models, props, and appropriate settings to influence the concept. The artist then gathers these materials, photographing those things that can't be carried back to the studio. He then prepares a full-sized black and white charcoal drawing, incorporating all the elements and defining every detail with typical Rockwell accuracy.

The composition thus established, the artist is free to venture into the less technical aspects of his work: Rockwell makes as many color sketches as necessary to satisfy his critical eye.

The final painting carries over more of the loose-

ness of the color roughs than the rigidity of the black and white stage. Rockwell allows his brushes and palette knife the freedom to treat textures and color blendings as a painting, rather than a drawing that has been colored.

Ex post facto

The Saturday Evening Post was the prime showcase for Rockwell's humor. From editor Ben Hibbs, responsible for buying the first covers from the young artist, to Kenneth Stuart, who promoted Rockwell's serious side (Stuart encouraged the world famous "Four Freedoms" paintings), the magazine's name engenders immediate association with Rockwell, its most popular cover artist. This unique artist–publisher relationship was to last over forty-seven years. It wasn't until 1963 that Rockwell finally left *The Post* to become involved in more pointed and controversial subjects.

Despite the symbiotic relationship between the two, *The Post* was not an easy mark. A cover idea was never sold on the basis of the signature at the bottom. Rockwell had to sell each idea as if it were his first.

"The best ideas," the artist recalls, "were always the 'naturals.' I knew I had a good one when I found myself so anxious to paint that I could hardly contain myself and wait for the okay. The ones that needed 'selling' to get across generally didn't make it. I might have been disappointed at the initial rejection, but later on, when I looked back at the idea more objectively, I almost invariably was happy I didn't do it.

"Some ideas stay with you for years without your ever resolving them. It took 'Gossip,' a cover I did for *The Post* (March 6, 1948) over twenty years to jell. Like so many problems, when I finally worked it out, the solution seemed so simple I couldn't understand why I hadn't thought of it before."

Rockwell's fifteen steps

Rockwell's working procedure has been carefully outlined in the most successful book this publisher, Watson-Guptill, has ever produced: *Norman Rockwell, Illustrator*. This definitive work is still available in a new printing that coincided with the historic Rockwell exhibit at The Brooklyn Museum, which later traveled the country. I urge the reader interested

The strong leftward thrust of the composition, emphasized by the rowing figures' forward lean, helps identify the focal point of the ad—the tourists—and adds the humor of the situation by contrasting the backward lean of the pleasantly frightened people "going native." Courtesy Pan American Airlines.

in particulars of Rockwell's approach to obtain a copy of the book; the synopsis that follows lists only the artist's fifteen steps, omitting the explanations that accompany them.

Step 1: Getting the Idea

Step 2: Getting the Idea Okayed

Step 3: Selecting the Models

Step 4: Gathering the Props

Step 5: Posing and Photographing

Step 6: Small Studies to Organize Material

Step 7: Charcoal Layout, Full Size of Painting

Step 8: Color Sketches the Exact Size of Reproduction

Step 9: Preparing the Canvas

Step 10: Transferring to Canvas

Step 11: Imprimatura

Step 12: Underpainting in Monochrome

Step 13: Color Lay-in

Step 14: Final Painting

Step 15: Framing and Delivery

In most cases, the step titles are self-explanatory or are covered, to some degree, in this chapter. Rockwell's procedure was obviously painstaking: he took no shortcuts. But this is to be expected from a man who says, "No man with a conscience can just bat out illustrations. He's got to put all of his talent, all of his feeling into them. If illustration is not considered art, then that is something that we have brought upon ourselves by not considering ourselves artists. I believe that if we would say, 'I am not just an illustrator, I am an aritst,' all works would show great improvement."

The humorous situation

The basis of most of Rockwell's humor is the vulnerability of the common man: forever caught in the com-

plexities of his time and social situation. His insecurities are exposed in a restaurant or baseball training camp; his confidence is tested at the end of a diving board or on an ice skating pond; the strength of his own convictions under attack (and obviously failing him) as he sits in his bathrobe on a Sunday morning with the newspaper, his family off to church. And so on down the emotional spectrum. Rockwell doesn't sit in judgment of his characters; he merely presents their conflicts (and always with understanding and love.)

There are times when a humorous idea cannot be executed within the framework of a single picture; for instance, when that idea relies upon the passage of time. It's a problem easily solved now that the two-part (before-and-after) composition has become an acceptable illustration form. But in August, 1947, when Rockwell's first two-panel cover appeared, it was an innovative attempt. Many contemporary art directors and editors believed it was the first time such a technique had been employed in publishing. The top panel consisted of a family embarking on what appears to be a Sunday drive in the country; the lower panel depicted their exhausted return. The idea is basic enough. Nothing startling or particularly

grabbing. It's Rockwell's treatment, the painstaking rendition of every detail of the energy-drained family that makes an idea as limited in scope as this one work effectively.

Influence of the old masters

Among others Rockwell was influenced by: Bridgman's emphasis on solid construction, Howard Pyle's decorative approach to picturemaking, A.B. Frost's "light touch" depiction of rural New England life, and Thomas Fogarty, his illustration instructor at the Art Students League.

Rockwell has been most influenced by the work of the old masters. The artist is forever searching through his collection of prints for new ideas and approaches to his art. It's interesting that the prints are not from any one time or school but represent titans of every age. "I don't wish to confine my thinking, influence, and inspiration to any one artist or trend, no matter how much I may admire that individual," Rockwell explains. The way someone can limit his mind and his work by copying current styles and trends, so might he be preventing growth and change by allowing only one frame of reference into his approach, even if it is an old master."

Studies for a "strength in reserve" poster designed for the U.S. Army Recruiting Publicity Office serve to illustrate the broad and subtle levels of emotion Rockwell is capable of portraying through deft use of facial expression.

Expression

We spoke of caricature more specifically in the Drucker chapter, but dealt with recognizable personalities. Rockwell uses caricature extensively, but only as part of the exaggeration process that takes place in his humorous work, not in his portraiture. Since the viewer doesn't know the person in the postman's uniform or barber's apron, Rockwell can concentrate more on the humorous aspects of the model's features and less on likeness. He can extend the mouth for a toothier smile or widen the eyes to increase the astonishment his subject is supposed to be expressing.

"For me", says Rockwell, "expression is the single most important factor in creating a humorous illustration. You can position the figure any way you wish, or plan a background that has limitless decorative possibilities, but it is the facial expressions that sets up your picture's theme, for only through the subject's expression can we learn how he is reacting to the situation. He may be smiling, but within the large spectrum of kinds of smiles is the one that will make or break the picture—and it is that smile we naturally must search for and record effectively.

"An embarrassed smile tells us one thing; a confident smile tells us something entirely different. We can then work from the facial expression to the other elements of the picture. The figure, of course, must develop the mood or attitude further. Careful attention must be paid to even the slightest gesture to be sure it becomes a natural extension of the facial expression."

Familiar subjects

Rockwell's subjects look familiar because everything about the picture—settings, models, incidents—encompasses and reflects an everyday scene. Rockwell would not paint a typical farmboy wearing current styles because that boy's wardrobe, in reality, lasts longer than passing fashion. The mismatch would be obvious and disturbing in the picture, unless of course it provided the humorous theme. Then, figure placement and total composition would be designed to emphasize the fact; Rockwell will spare no pain to find and utilize the proper location, models, costumes, and props. In his own words:

"I am convinced that every single object shown in a picture should have its place there because it contributes to the central theme of the picture."

Rockwell's feeling about what he paints is obvious: he loves it, and his humor stems from that love. While people and places are more than accurately documented, Rockwell doesn't drive his point home with a hammer. Not unlike Thomas More, who punished his children by "beating them with an ostrich feather," Rockwell's point is made gently—tickling rather than cracking the funny bone.

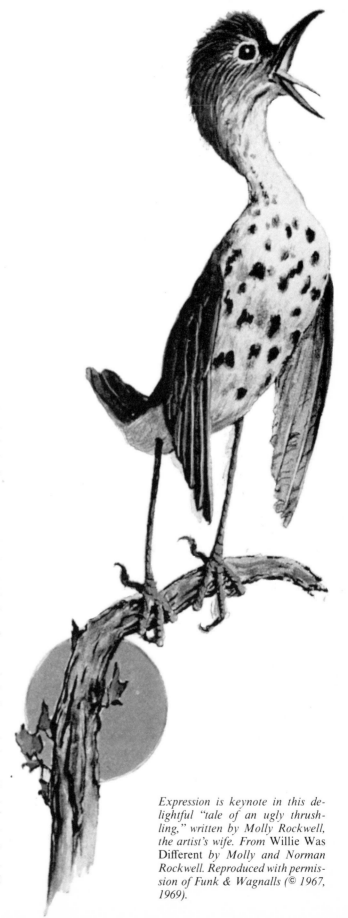

Expression is keynote in this delightful "tale of an ugly thrushling," written by Molly Rockwell, the artist's wife. From Willie Was Different *by Molly and Norman Rockwell. Reproduced with permission of Funk & Wagnalls (© 1967, 1969).*

The artist as director

Rockwell's dedication to realism doesn't preclude taking certain liberties with character casting for his painting. He works toward as close a marriage as possible between his mind's image and that on the canvas. Thus, when he wished to portray a maternity waiting room filled with expectant fathers, he was able to find those nervous, tired, and fidgety types in an advertising agency. Rockwell found that atmosphere tenser than the actual hospital scene (several new fathers were asleep from exhaustion, while the more experienced remained relatively calm, chatting or reading magazines). Rockwell wanted to capture that endless time, which he remembered so vividly from when he himself waited for his first child to be born.

Finding the proper characters is only the beginning. "You must be a sort of movie director to get the most out of your model," says Rockwell. "Almost anyone can act if given enough encouragement; so do the posing yourself to help the model lose his self-consciousness and get the feel of the idea. I can create my conception of the character and the situation" he continues. "Photographs are a great timesaver and I don't know how I could get through my work without them."

The relevance of humor

"I say what I want to say in terms of ordinary people in ordinary situations," explains Rockwell. "And I paint the kind of world I think should exist; life as I would like it to be. Ours is a frightening world, and people are reassured by simple human decency. I paint a happy world because that's what I see. I can't paint the seamy side of life. The people I paint represent the things I like best about the American character."

In an age filled with gray, ominous skies, *relevance* has become a key word. There is no room for the humorous and sentimental in art. It is as though we must be forever reminded of what's wrong with the world. Aren't a few moments of what *should be* or *could be* as relevant as what *is*? And isn't every strong, personal feeling or conviction relevant? The positive is as valid as the negative. Why, then, this value judgment of one less important than the other? Rockwell feels very strongly about his subjects. His perception and point of view about humorous ideas are as much a part of him as his more serious side.

An artist feels the need to touch, but his impact needn't be negative. To entertain should not be judged as something less than to shock or to educate. It's the Walt Disneys and the Norman Rockwells who can create visual worlds that are neither complete fantasy nor total escape, but simply a welcome respite from a sometimes harsh reality.

Ever a student of the old masters, Rockwell impishly bases his conception of "The Recruit" (opposite page) on the Michelangelo statue of Giuliano Medici (right), just as he had based his famous "Rosie the Riveter" for the Post *cover of May 29, 1943, on this same master's fresco of the Prophet Isaiah (© 1966 by Cowles Communications, Inc.).*

(Above) Summer is over, school has started again, and the boys look sorrowfully at the old swimming hole, the scene of so much of their pleasure such a short time ago. From The Norman Rockwell Storybook, (told) by Jan Wahl. Courtesy Simon & Schuster, Publishers.

(Right) "Easter Morning." Expression is often the icing on the cake in a Rockwell painting, the extra touch that makes a good idea a little better. But in this particular cover design, the idea is completely dependent upon facial expression to tell the story as well as carry the humor. Reprinted with permission from The Saturday Evening Post (© 1959 by The Saturday Evening Post, Indianapolis, Indiana).

The Saturday Evening

POST

May 16, 1959 – 15¢

Our Gamble With Destiny

By STEWART ALSOP

WARNING TO YOUNG MEN By Eric Sevareid

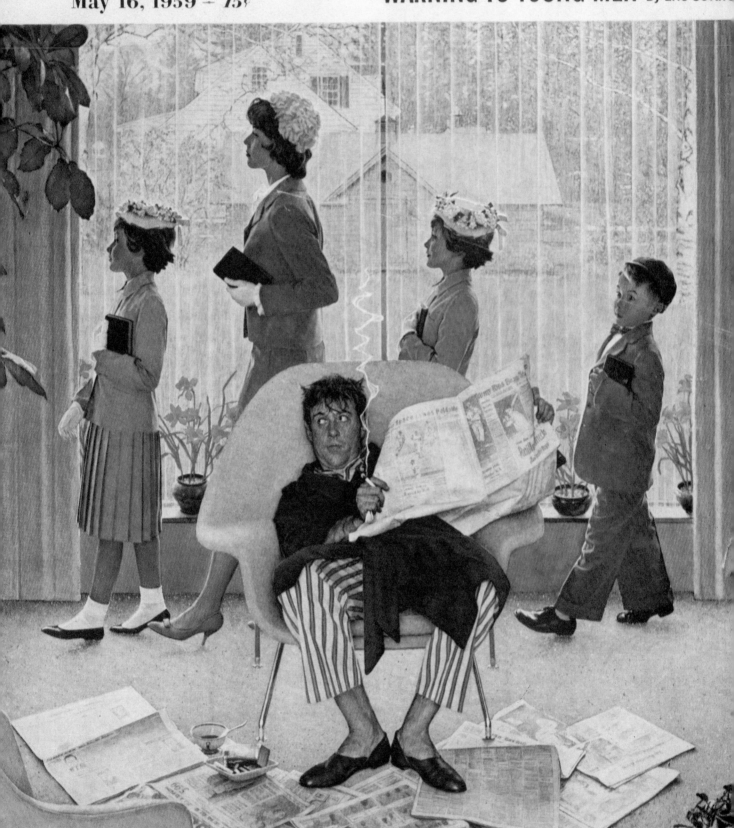

Arnold Roth

Style and Individuality

"A style is not something you begin with," suggests Arnold Roth. "It's something you arrive at. A style evolves. Many novices make the mistake of contriving a style—usually bits and pieces picked up from others—as if a self-conscious compilation of influences will automatically make it something new and original. In the process they have constricted their growth and choked the potential of their own personalities. *Individuality* (which is what style is all about) is the real loss."

How does one go about getting a style? One draws pictures, many many pictures. Pictures of people and cars and dogs and nectarines! And after enough drawings have been made, one looks through the huge pile. The drawings will vary from rapid, incomplete sketches, to detailed, labored renderings, with various stages in between. Chances are they will all have some common facet or a thread, however thin, linking them together. That's *style!*

All play and no work

Roth attended Central High School in Philadelphia. With encouragement and direction from his art teacher he was able to qualify for a scholarship to the Philadelphia College of Art. He knew from the beginning that his art interests were inclined toward humor rather than the more serious work. But he also knew that his parents' financial situation made it necessary for all family members to help out. So Roth, who played the saxophone, began accepting more and more club dates with local jazz groups. Roth's nightly engagements lasted until five in the morning; his classes at college began at nine. These insane hours kept him barely conscious during class, let alone capable of keeping up with home assignments. Consequently, his instructors just thought of him as not taking his work seriously, which was probably true—by definition. He was expelled after two years of record-setting lateness. Then, after a year's recuperation from tuberculosis, he started his free-lance career by painting "roosters and hex signs" for a local lampshade manufacturer as well as providing spot drawings for neighborhood newspapers and publications.

In school, Roth had delighted in learning the classical and traditional approaches to art, such as mixing rabbitskin glue with powdered pigments for underpainting on canvases and wood panels, applying the oil and egg tempera techniques of the old masters, working on murals and frescoes, etc. He credits that stage of his life with developing his artistic tastes and attitudes.

Roth realized that being funny was largely instinctive. However, that capacity can be enhanced by artistic proficiency. There are many different approaches and levels to making a humorous point. He learned that style should not be a way of covering up that which you don't know or can't draw, but a way to exaggerate or parody that which you *do* know and *can* draw—and so he drew everything! The better he got at drawing, the more confident and free he became in altering and exaggerating forms. Subsequently, Roth was able to derive more humor from familiar elements.

He always studied the humorous artists of the past, most notably Rowlandson, Cruikshank, and Hogarth, as well those he believed to be the best contemporaries, like Ronald Searle. "I believe that Chester Gould (creator of *Dick Tracy*) is an expressionist genius, much like Max Beckmann," Roth states. "And Harvey Kurtzman (originator of *Mad, Trump, Humbug,* and *Help* magazines and *Playboy's Little Annie Fanny*) has had more effect on today's comic artists than perhaps any other individual on the humor scene."

Commitment and compromise

Working with Kurtzman on *Trump* and *Humbug* magazines had a great impact on Roth. He was encouraged to greater introspection in his search for individual expression. He also learned about commitment from this humorist whose uncompromising efforts toward perfection have become legend. When both *Trump* and *Humbug* folded, Roth created a Sunday page feature entitled *Poor Arnold's Almanac,* bought and syndicated by *The New York Herald Tribune.* Here the artist utilized some of the insights gained from his magazine work, such as his "visual essay" approach to the subject.

Each week Roth would apply his own special brand of humor to another topic. A visual dessertation on "whatever happened to pop into my mind or

come up in conversation that week." As the artist recalls, "I would also bounce back and forth into American history, one of my favorite *serious* subjects, and have fun with well-known incidents or familiar eras." Roth's drawing approach has developed a great deal since that time. His ability to inject a flavor of the absurd into cliché situations is still apparent, however, in his articles for *National Lampoon* (usually visual essays) his illustrations for *TV Guide,* and his features for *Sports Illustrated,* and *Punch* magazines.

Punch, the British weekly humor magazine, is an account Roth is especially proud of as few American writers or artists have been represented in its pages. "My association with *Punch* came about while *Poor Arnold* was still running. I had read all of Dickens, studied the English artists, and felt that a few years at the *source* would be important to my growth. So I packed up my family and we took off for London. I was there for one year, during which time the strip was cancelled. I continued to do other work from the States through the mails, and was immediately successful with *Punch.* To this day I work regularly for them.

The business end

"Art is a profession where more things happen to you than you can make happen," says Roth. "You can't really plan ahead or predict. All you can do is work hard, take a steady course and hope that the good things that happen will outweigh the bad."
Roth's approach to the business end of humorous

illustration is more realistic than pessimistic. He has learned, as all artists must, that not everyone is going to react to your work in the same way. Art is not a scientific profession and there are no absolutes. Success or failure is based on taste and opinion, sometimes individual, sometimes cumulative. The situation is chancey at best. An art director who likes your work may move on or be replaced by one who doesn't—and there goes an account! A client may be shown by some survey or research into the subject that he'd get more mileage out of another media—and there goes another account! An editor you have an appointment with on Tuesday morning may have an argument with his wife the Monday night before—and so forth.

Unlike many other businesses where ability can be measured in more concrete terms, an artist has to be in the right place at the right time with the right sample! It's a difficult professional fact, impossible to manipulate or control. "It's also a question of the end product," adds Roth. "In financial situations, a stockbroker's end product is money. The end product of a cartoonist's effort is a funny picture. It's imperative that it be printed—otherwise it's like telling erotic stories to yourself. The trick to the whole exercise is to make a living while all this is going on. Probably the funniest thing about cartooning is that all these things can, and do, happen!"

Changing times

Illustration, Like all other communication media, is undergoing change. The traditional approach carries far less weight now than ever before: classical music,

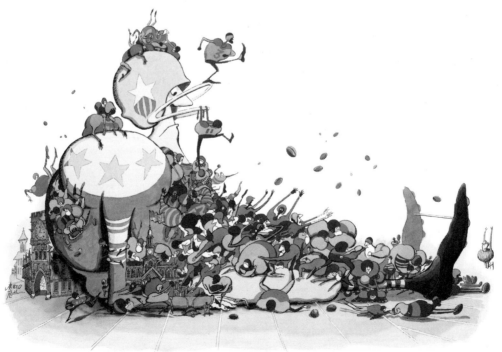

Using highly expressive line as a basis for the greater portion of his work, Roth's illustrations hold up well in every form of reproduction, even full color transposed to black and white, as in this example. Courtesy Sports Illustrated *(© Time Inc.).*

painting, theater, and dance—though still supported by an enthusiastic and loyal following—must compete for attention with their modern counterparts. You can no longer assume anything. Even in so prominent and traditional an auditorium as Carnegie Hall, a concert may be rock as easily as Mozart.

The popular arts, especially film, television, and magazines, reflect the society in which they are created. It's a society that questions, abhors dogma and rhetoric, prefers movement to roots, and creates its own rules and regulations to fit its needs, however transient or temporary.

"Invention is no longer paramount," observes Roth. "Expression is again becoming more important. Promise doesn't offer as much as results. The philosophical question 'is it better to be *first* or *best*?' is answered 'best' without hesitation. Who was the *first* painter in oils? Who cares! But who was the *best*? *That* matters! Like everyone else, I don't know if this volatile lifestyle will prove to be constructive or destructive. I tend to be optimistic, but the main thing is that it's the present and we must deal with it as best we can."

Humor today

The star system has practically vanished. It no longer takes a *name* to pack a movie house or sell a magazine. Years back names of certain illustrators were household words, but that isn't the case today. *Who* does it is less important than *how* it's done. This particular change is certainly for the better. It allows greater freedom and avoids the repetition of an artist concerned with a style or his reputation. For instance, earlier humorous illustrators were often too literal, their work restating what had been described verbally. Today, a humorous illustrator is expected to interpret or expand an idea. "In my own work," declares Roth, "I often use allegories and metaphors to make my visually humorous point. Or I'll try to be the Marx Brothers on paper—slapstick and crazy. Or work whimsically, which is softer and less zany but, very often, too easy to do—like a guy with a cannon shooting at a daisy or 50,000 birds flying one way and one bird flying the other way. This freedom sits well with my basic outlook and philosophy: don't take anything too seriously. It's only real life. Now Ingmar Bergman—that's serious!"

Today there's more tolerance and acceptance of iconoclasm than ever before, even to the point where being outrageous passes for being humorous. Satire doesn't necessarily "close on Saturday night," as George S. Kaufman once quipped. Humor in all media finds very little in life that isn't fair game.

Unfortunately, theories about humor, however valid, are nearly impossible to apply consciously. Observation, research, and study should serve to facilitate the artist's instincts. One cannot always afford the luxury of complete awareness. You can cerebralize a funny idea to death if you begin to analyze and apply theory at the onset. People will respond to a concept only if it's funny and all the brilliant rationalization and explanation won't make a bit of difference if the reader has not responded with a laugh. That can only come with time, practice, and experience—and it must come naturally.

The artist naturally pays more attention to his line in drawings where neither color nor tonal stages are employed. Courtesy Punch *Magazine.*

The character of line

An artist's *line* is an oft-used and misused descriptive term. A line depends more on how its drawn than who's drawing it. No artist has a copyright on a particular method, but many artists do become associated with a certain look or approach. Like *style*, a line evolves rather than being created. It's an extension of one's outlook and personality and must develop accordingly if it's to be a natural vehicle for expression.

Roth's pen work has many "lines." They range from scratchy and sensitive to bold and black. Each approach is matched to the job by feel rather than formula. This full range of line work is especially effective when budget or layout prohibits the use of color and Roth has to "supply his own" via black and white. "Black and white is color with a very limited palette," offers the artist. "Line can be very colorful, especially if the blacks are handled well. Design possibilities are endless. You can achieve depth and form simply by playing densely worked areas against white space. Or you can use black as a color by brushing it on flatly in a way that destroys volume. To maintain clarity I try not to confuse the blacks used as color with darkened areas that suggest light and shade."

Materials

"Most of my work is with pen," states Roth. "I generally pick a nib from this huge assortment of crazy points that has accumulated through the years. I pick points like I do ties—*badly*—and sometimes even end up using my old reliable Gillott #404. I prefer watercolor to other color media, usually working in a combination of pen line and color. I use only high quality paper (Fabriano, D'Arches, J. W. Green, RWS, etc.). I've learned through experience that there's a direct correlation between good paper and good reproduction, at least with my work."

Roth soaks the watercolor paper long before stretching it over a wooden drawing board. He secures it on all four edges with a double row of staples. Wetting the surface of watercolor paper serves two purposes: first, it removes any finish or foreign matter that may interfere with even absorbency; second, it produces a shrinking action. As the paper dries out it shrinks slightly and leaves a taut, springy working surface. The picture is drawn in pen and ink.

After the color stages are completed, Roth goes back to the pen and ink to build up line work in areas he wishes to emphasize or those that have become subdued or overpowered by the color.

"I haven't had too much success with mechanical pens" says Roth, "although a new one, the Higgins Boldstroke, has worked well on my last two jobs. I prefer a flexible point, and no fountain pen I've ever tried compares with the 'dip points' for that. Bold-

Roth's approach to even symbolic clichés, such as Notre Dame's mascot leprechaun, can be expected to be more imaginative than the typical, more literal interpretations we're generally exposed to.

Roth's horses may be a breed unto themselves, but what they lack in accuracy they more than make up for in style and originality.
Courtesy Sports Illustrated *(© Time, Inc.).*

stroke is a nylon point pen with India ink cartridges and has a nice steady flow. I like fooling around with new materials and gadgets because you're never quite sure of what's going to happen with them. Materials you've used over and over are reliable, but also predictable. Sometimes happy accidents occur when you try out different media and techniques (accidents that could never happen with the old tools). The process is basically finding out what you're *not* searching for, allowing unplanned discoveries to take place then utilizing them when the need arises. The result becomes more personal and meaningful when *you* gain some control but still work *with* your materials. Nothing you can imitate or contrive will be as effective or rewarding."

Roth is not compulsive in his art, merely dedicated. He does not judge his production by how *many* but by how *good*—and works toward that end. Thus a drawing is finished after he's given it all he can, not a moment before. The reason is simple enough: Roth loves to draw. Roth's attitude toward drawing brings to mind a paragraph from an article written by Ben Shahn, *About Bernarda Bryson* (his artist wife): "Fully aware, as she is, that drawing—in the sense of good draughtsmanship—has been de-emphasized to the point of exclusion in the new art teaching and in criticism, she takes great pleasure in the most scrupulous draughtsmanship. She says, "I really love to draw—why shouldn't I?""

Shahn, with a twinkle in his eye, speaks of the demand of "elegance" his wife made upon herself. The tongue-in-cheek tribute actually carries an inspirational message to those artists who dare to be individuals—artists like Arnold Roth.

(Above) Roth perfected his panel-by-panel humorous essay approach in his Sunday comic feature, Poor Arnold's Almanac.

(Right) Roth endeavors to match his approach to the subject, choosing a more classic approach for his illustrations for Grimm's Fairy Tales *(©1963 by Macmillan Publishing Co., Inc.).*

A continuity must have consistency in both mood and technique in order to be effective. Any disturbance or contradiction to the visual flow will weaken the work considerably, and the humor will suffer accordingly. Roth, through clever use of line and tone, creates the mounting tension in "The Good Sport." Courtesy Sports Illustrated *(© Time, Inc.).*

(Right) Roth exaggerates the forms to portray the seemingly contradictory combination of muscle and grace that go into a professional hockey player. Courtesy Sports Illustrated *(© Time, Inc.).*

(Below) Here the artist exaggerates an idea to illustrate the genius of the young Mozart, who is seen composing as fast as his work is performed.

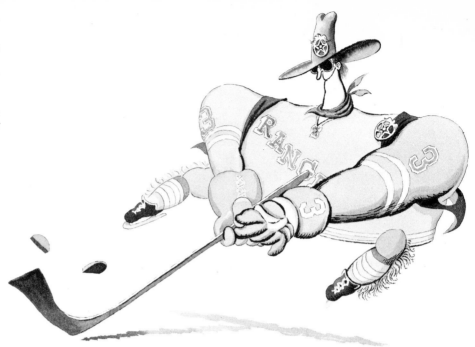

And how are we feeling today, Room 207?

(Left) In this broad view of the medical arts, the artist reveals his feelings about the concern displayed by hospital doctors. *Courtesy* Punch Magazine.

(Below) Here the artist offers a suggestion for the neglected housewife during the football "home season"—open up a few concessions and make a few bucks! *Courtesy* TVGuide Magazine.

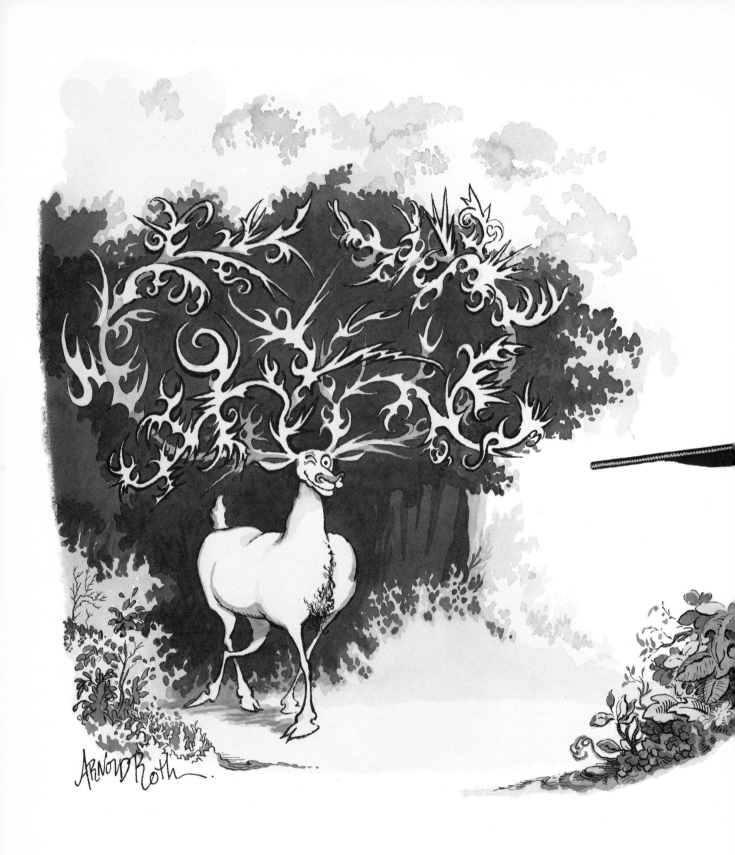

A lot can be said about the artistic merits in a Roth design, but we too often forget a basic ingredient—fun—which the artist always manages to make a part of his work. Courtesy Sports Illustrated *(© Time, Inc.).*

From Where the Wild Things Are *by Maurice Sendak (© 1964 by Maurice Sendak). Reprinted by permission of Harper & Row, Publishers, Inc.*

Maurice Sendak

Children's Books

"I remember," states Maurice Sendak. "I think most of us who create books for children do. We don't have a particular recall of what happened day by day, but there is an emotional recall. I remember feelings and sensations in a strange way, and I transmit them to my work."

The children's book field is a curious one. The product is created for children, but it's the purchasing power of the adult that determines its success—and publishers are well aware of this. It's the artist, however, that must bridge the two worlds: he must call attention to the book on both levels. A more sophisticated illustrative approach may appeal to the adult as he browses through the bookstore, but this same approach may meet with the child's disapproval. The reverse, of course, also holds true. Drawing on a child's level is a nearly impossible task for an adult. It will repel the average adult looking to educate while entertaining the child. Anything that appears to be truly childlike (which he interprets as condescending) will be judged beneath the child's level. Consequently it will not be purchased.

Appealing to the adult, then, appears to be the more financially sound choice. But the real success of a children's book is a long-range proposition. It depends upon word-of-mouth recommendation and library and school re-orders. Long-range, too, are a publisher's prestige and dependability and the artist's reputation. One way to approach this dilemma is to work for *personal* satisfaction. Working with sincerity and integrity has always been rewarding in art and, usually it's the best way to satisfy others.

This philosophy clearly defines the Sendak approach. Rarely has the children's book field produced as dedicated an artist as Sendak, and rarely has any children's book illustrator achieved his success. He's been awarded the American Library Association's Randolph Caldecott Medal and in 1970 became the first American to receive the coveted Illustrator's Medal of the world-wide Hans Christian Andersen Awards. Such tribute could not be paid to a more deserving or appreciative man, for books are and always were Sendak's life. "As a child," the artist says, "I felt that books were holy objects to be caressed, rapturously sniffed, and devotedly provided for. I gave my life to them—I still do. I continue to do

what I did as a child: dream of books, make books, and collect books.

"I was fortunate to have received the best art education available for illustrating children's books: *illustrating children's books*. While my first attempts were crude (I still don't know how I was able to get more work on the basis of them), the important thing was that I *did*. And every drawing from that time on became a course in children's book art, or at least I made it that."

The importance of movies and store windows

Sendak was born and raised in Brooklyn, New York. As a youth attending Lafayette High School he dreamed of being a cartoonist. He went so far as to write a letter to his hero of heroes at the time, Walt Disney. "*Fantasia*," Sendak recalls, "was perhaps the most esthetic experience of my childhood—and that's a very dubious experience. But mainly there were comic books and Walt Disney and, more than anything else, the movies with their exotic, glossy fantasticalness. They permanently dyed my imagination a silvery Hollywood color. Aspects of the movies that might be rejected by an adult mind were perfectly suited to a child devoted to making up stories and, from an early age, putting them down on paper. The pleasurably dreaded King Kong, the graphically vivid, absurdly endearing figures of Mickey Mouse and Charlie Chaplin were the most direct influences on me as a young artist."

While still a high school student Sendak's drawing ability was proficient enough to gain him his first professional assignment. This was to illustrate an explanatory book about nuclear energy titled *Atomics for the Millions*. ("Dreadful pictures," says Sendak.) A year after graduation he began his art education at the Art Student's League, studying with John Groth. Groth taught Sendak to look at Daumier, Goya, and most important to carry a sketch pad wherever he went. On-the-spot work taught Sendak to see more (which he could then translate into humorous observation) and to develop his eye for authentic detail. Both are major parts of his illustration today.

Despite his love of books, Sendak actually "backed into" his first important book assignment. He and his

brother Jack, a "creative engineer," designed and constructed several toys that moved about with clever lever action. They took their efforts to the famed Fifth Avenue toy store, F.A.O. Schwarz. The toys, they were told by officials of the firm, would be too costly to be mass-produced for the commercial market. They were so impressed with Sendak's artwork and decoration, however, that they offered him a job as a window display artist. He accepted.

It was in this capacity that Ursula Nordstrom, editor of the children's book division at Harper and Row, noticed Sendak's work. Passing the imaginative windows month after month, she finally entered the store to inquire about their creator. An appointment was set up at Harper and Row and Sendak's career as a book illustrator was launched. (Sendak and his brother collaborated again when Jack sold several of his picture book ideas to publishers who contracted Maurice to illustrate two of them.)

The draftsman today

In an age of mass production, automation, and instant coffee, the days of the hand craftsman are num-

bered. Profits are measured in terms of speed and fast turnover. The term *quick buck* never had more meaning than today.

Art, if it is to remain a vital force, must mirror the changes taking place in the world it represents. Subject matter, approach, and even media must reflect their own eras. Many painters now use acrylics exclusively, shunning the slow qualities of oils for the fast-drying, mix-and-clean-with-water properties of their polymer counterpart. The representational approach is in the minority. The emphasis today is mostly on the abstract. Subject matter is seldom romantic. More than any other time in the history of art, the canvas has become a sounding board for the voice of protest. Thus the emphasis is often on *dis*: dissatisfaction, disenchantment, disappointment, and distress. But in terms of craftsmanship, there seems to be a trend away from discipline. In many areas of illustration, for instance, different varieties of tracing machines are employed to cut down—if not cut out completely—the drawing stage of the work. Photos are projected directly onto the drawing surface and the image is copied. Design in ads, posters, covers, etc., leans toward the bold and the abbre-

From Where the Wild Things Are *by Maurice Sendak (© 1964 by Maurice Sendak). Reprinted by permission of Harper & Row, Publishers, Inc.*

viated. Is the trend coincidental or part of a movement away from the traditional concepts of draftsmanship? Are the changes esthetic or economic at the roots? The answers are not easily determined. However, in most cases a simplified approach demands less time but not less money. The time necessary to produce work in the "old school" manner might prove disastrous to an artist trying to feed his family. Consequently, the "long way around" has given way to the "short cut."

The humorous illustrator was usually spared these options. His career and reputation were built on his ability to entertain rather than dazzle with technical expertise (not that this wasn't helpful, it just was not a requisite).

Sendak is a throwback to that philosophy. While he has the ability to entertain, he doesn't begin and end with that ability. Responding to good draftsmanship, he offers more than lip service to craftsmen. He has at times spent weeks on a single illustration, only to discard it for not coming up to his expectations. He does not overstate or render for the sake of rendering. He simply gives every square inch of drawing space everything he's got, whether left blank or filled with intricate pen work. He does this without resorting to trick or gimmick, technique or style. As Sendak says:

"Style to me is purely a means to an end, and the more styles you have, the better. One should be able to junk a style very quickly. I think one of the worst things that can happen in some of the training schools for illustrators is the tremendous focusing on 'style' as preparation for coming out into the world and meeting the great horned monsters—book editors. And how to take them on. Style seems to be one of the things you learn as a defense. It's a great mistake. To get trapped in a style is to lose all flexibility. I've worked very hard not to get trapped in that way. Now I think my work looks like me, generally speaking; look over a series of books and you can tell I've done them (much as I may regret many of them). I worked up a very elaborate pen and ink style in *Higglety*, which is very finely crosshatched. But I can abandon that for a Magic Marker, as I did with *Night Kitchen*, and just go back to very simple, outlined, broad drawings with flat, or flatter, colors.

"Each book obviously demands an individual stylistic approach. If you have *one* style, then you're going to do the same book over and over. That of course

is pretty dull. Lots of styles permit you to walk in and out of all kinds of books. It's a great bore worrying about style. My point is to have a fine style, a rough style, a fairly slim style, and an extremely fat style."

Materials match the approach

Sendak begins the drawing stage of his work by making dozens of pencil sketches, using everyday #2 writing pencils on light bond paper or tracing pads. He then takes the "parts that work" and begins compilation drawings, modifying the overall composition as he goes along. When the desired effect is achieved, he transfers the work onto a single-ply, cold pressed Strathmore paper by retracing it on a light box.

Pen drawings, the major technique in the Sendak repertoire, are usually executed with a Hunt 102 crowquill nib and India ink. For special effects, Sendak will use whatever material he feels best suited to the particular approach, i.e. markers to get a blunt line (reminiscent of the coloring book flavor in *Night Kitchen*).

Sendak has found jars of RichArt tempera paint diluted with water an ideal color medium for transparent watercolor techniques. Their flat, straight-from-the-jar consistency makes them suitable for opaque passages as well.

Influence and inspiration

While Sendak freely admits that he'll "borrow from anything and anyone that will help me achieve what I'm after," the artist speaks from a position of security and confidence in his own talents. It's an admission too few will make for fear of compromising their images as creative artists. For all Sendak's influences, his work emerges as highly personal. Sendak pays

From Mr. Rabbit and the Lovely Present *by Charlotte Zolotow, illustrated by Maurice Sendak. (Text © 1962 by Charlotte Zolotow, pictures © 1962 by Maurice Sendak.) Reprinted by permission of Harper & Row, Publishers, Inc.*

tribute to those whose work inspired his approach to a particular book or series of drawings, but inspiration is worlds apart from imitation.

The metamorphosis of Sendak's original idea from visceral experience through conception and ultimate rendering can never be predetermined. Therefore it can never be copied from anything already in existence. In Sendak's case, his influences have been his education: old means that the artist has turned to new ends. In his own words:

"Many of the artists who influenced me were illustrators I accidentally came upon. I knew the Grimm's *Fairy Tales* illustrated by George Cruikshank. I just went after everything I could put my hands on illustrated by Cruikshank and copied his style. It was quite as simple as that. I wanted to crosshatch the way he did. Then I found Wilhelm Busch and I was off again. But happily Wilhelm Busch also crosshatched so the Cruikshank crosshatching wasn't entirely wasted. And so an artist grows. I leaned very heavily on these people. I developed taste from these illustrators.

"The 1860's, the great years of the English illustrators from whom so much of my work is derived, are familiarly known as "the sixties" to admirers of Victorian book illustration. The influence of Victorian artists such as George Pinwell and Arthur Hughes, to name just two, is evident in the pictures I created for *Higglety Pigglety Pop!* (Harper and Row, 1967), *Zlateh the Goat* (Harper and Row, 1966), and *A Kiss for Little Bear* (Harper and Row, 1968). And I've learned from other English artists as well. Randolph Caldecott gave me my first demonstration of the subtle use of rhythm and structure in a picture book. *Hector Protector and As I Went Over the Water* (Harper and Row, 1965) is an intentionally contrived homage to this beloved teacher.

"For other fine points in picture book making, I've studied the works of Beatrix Potter and William Nicholson. Nicholson's *The Pirate Twins* certainly influenced *Where the Wild Things Are* (Harper and Row, 1963).

"A retrospective of my English passion can be found in *Lullabies and Night Songs* (Harper and Row, 1965). The illustrations for this book, which skip from Rowlandson to Cruikshank to Caldecott and even to Blake, are a noisy pastiche of styles, though I believe they still resonate with my own particular sound. *Mr. Rabbit and the Lovely Present* (Harper and Row, 1962) is as far as I am aware the only book I've done that reveals my admiration for Winslow Homer.

"About two-and-a-half years after the publication of *Where the Wild Things Are*, I finally became conscious of my reviving interest in the art I've experienced and loved as a child. The trigger was an exhibit (at The Metropolitan Museum) of pages from *Little Nemo in Slumberland*, Winsor McCay's famous newspaper comic strip of the years 1905 to 1911. Before the exhibit I was ignorant of this popular American artist's pure genius for graphic fantasy. It now sent me scooting back with new eyes to the popular art of my own childhood.

This recognition of personal roots is in no way meant as a triumphant revelation or as reverse snobbism, a put-down of my earlier, more 'refined' influences. What I've learned from English as well as French and German artists will, if I have my wish, become more absorbed into my creative psyche, blending and living peaceably with my own slice of the past. But of course all this happens on its own or it doesn't happen at all."

Imitation is something else. In most cases imitation is what the less creative resort to consciously, as if mimicry will elevate them to the level of those they copy. While there was no "Sendak" in the field before Sendak, there are several now—possibly spurred by editorial directives. Certainly the "imitation is the sincerest form of flattery" rationale doesn't hold in commercial art. Saturation of a successful approach by others forces the innovator to abandon it or become an imitation of himself. The major crime here is that the original artist cannot participate fully in the rewards of his effort.

Writing for children

Following Sendak's success as illustrator of several Harper and Row books (most notably Ruth Krauss' *A Hole is to Dig*), Ursula Nordstrom encouraged him to write. She felt Sendak's depth and imagination would be best utilized if he also *wrote* his own books. His first success, *Kenny's Window*, was published in 1957. This was followed by *Very Far Away* (1958) which Sendak describes as "a rough sketch for the later *Wild Things*." He continued this one-a-year output of his written and drawn books with *The Sign on Rosie's Door* (1959), but didn't experience real commercial success until 1960 when his unique *Nutshell Library*, a mini-collection of four tiny books, was published.

"There are two essential elements in writing for children," Sendak states. "One is fantasy. The other, the make-believe, is a very thin covering for a tremendous reality, a poignantly happy or terribly unhappy drama of personal emotions: feeling and living and dying.

"Fantasy is so all-pervasive in a child's life. I believe there's no part of our lives, adult as well as child when we're not fantasizing, but we prefer to relegate fantasy to children—as though it were some tomfoolery only fit for the immature minds of the young. Children do live in fantasy and reality; they move back and forth very easily in a way that we no longer

remember how to do. In writing for children you just must assume they have this incredible flexibility, this cool sense of the logic of illogic, and that they can move with you very easily from one sphere to another without any problems. Fantasy is the core of all writing for children, as I think it is for the writing of any book, for any creative act, perhaps for the act of living. Certainly it is crucial to my work.

"All my books are journeys, literally trips into fantasy. It's my one theme. Through imagination kids get *away* from a situation, out of a house where no one is interested in them, out of a place where they're bored. Children, and the characters in my books, accept life if they know they can go away for a few minutes, have a real fantasy orgy and do all the things that are pent up, just to get it out of their systems."

Words and pictures

Ideas for books generally evolve from Sendak's past; seldom, if ever, from drawings he's made. Sendak's art is his attempt to capture graphically that fleeting memory or well-etched image that appears in his mind's eye. The artist explains:

"When writing, I don't think of the pictures at all. It's a very strange, schizophrenic sort of thing; I've thought of that very often. Sometimes after I've written something I find that there are things in my story that I don't draw well. And if it were any other person's book I'd consider not doing it. But I've written it and I'm stuck with it, which is proof to me that I have not (at least consciously) been seduced by the tale's graphic potential. I don't think in terms of pictures at all. I find it's much more interesting and difficult to write, so that illustration has become secondary in my life. So far as I'm aware, I think strictly in terms of words. And then when it's finished, it's almost a surprise as to 'How'm I going to draw that?' or 'Why did I do that?' I'm stuck with an airplane, or I'm stuck with a building. If I'm stuck with an automobile, I'm ready to blow my brains out.

"In the characters there's a kind of progress from holding back to coming forth. I'd like to think it's me,

Two drawings from Zlateh the Goat and Other Stories *by Isaac Bashevis Singer, illustrated by Maurice Sendak. (Text © 1966 by Isaac Bashevis Singer, pictures © 1966 by Maurice Sendak.) Reprinted by permission of Harper & Row, Publishers, Inc.*

not so much as a child or pretending that I'm a child, but as a creative artist who also gets freer and freer with each book and opens up more and more. For instance, when I was a child there was an advertisement that I remember very clearly. It was for the Sunshine Bakers. The advertisement read: 'We Bake While You Sleep!' It seemed to me the most sadistic thing in the world, because all I wanted to do was stay up and watch. And it seemed so absurdly cruel and arbitrary for them to do it while I slept! This frustration of so many years back was not an energy that dissipated with time. It remained a force that I was able to harness, control, and channel into *Night Kitchen* to complete my revenge.

"My passion for making books has lately led me to a distinct vision of what I want my books to be, a vision difficult to verbalize. I no longer want simply to illustrate—or for that matter simply to write. I am now in search of a form more purely and essentially my own."

Levels of laughter

There are many levels of laughter. While the response to a clever line or slapstick routine can be the same, both generate different kinds of feelings within.

"With myself," Sendak goes on, "it's usually cerebral or visceral. When I watch a Chaplin film, for instance, I'm laughing at his comic genius. I'm aware of what he's doing and enjoy it immensely since he's doing it so well. But it remains strictly on a cerebral level. Buster Keaton, on the other hand, affects me differently. I can identify more with him, so I get lost in his portrayals. It's total involvement. I try to maintain that from-the-gut feeling in my work. It's more rewarding to me and has proven to be what makes the readers react so favorably. Obviously we're all looking for a more visceral experience."

It's no coincidence that Sendak uses old film stars to create his analogy. Films played a most important role in his boyhood. Nor is it coincidence that not one but *three* Oliver Hardys show up as the bakers in Sendak's memorable *Night Kitchen*. And what of Stan Laurel, Hardy's brilliant counterpart? "I wanted *bulk* in *Night Kitchen*," Sendak replies. "No slight to Stan Laurel was intended. I stuck to my original concept of three fat cooks and cast Hardy in the collective part."

It's precisely these touches that bring to Sendak's work that improbable, illogical flavor that makes it so true. The child's mind is not hampered by rational restrictions. He can accept his own fantasy world as easily as he can accept Mickey's in *Night Kitchen* or Max's in *Wild Things*—or the fantasy world of the man who says it better and draws it better than anyone in the history of children's books: Maurice Sendak.

Two pen renderings from Higglety Pigglety Pop! or There Must be More to Life *by Maurice Sendak (© 1967 by Maurice Sendak). Reprinted by permission of Harper & Row, Publishers, Inc.*

152

A drawing from In the Night Kitchen *(top) as it appeared before color was added. The same drawing reproduced from the pages of* In the Night Kitchen *(bottom).*

(Overleaf) The marvelous double-page spread from In the Night Kitchen *by Maurice Sendak (© 1970 by Maurice Sendak). Reprinted by permission of Harper & Row, Publishers, Inc.*

From Zlateh the Goat and Other Stories *by Isaac Bashevis Singer, illustrated by Maurice Sendak. (Text © 1966 by Isaac Bashevis Singer, pictures © 1966 by Maurice Sendak.) Reprinted by permission of Harper & Row, Publishers, Inc.*

Afterthoughts

A book of this type isn't *written* in the normal sense, it's *put together*. It doesn't start on page one and end on the last page. Chapter 12 might have been written before Chapter 11, and, in fact, it *was*, but alphabetical order prevailed. Like a jigsaw puzzle with pieces that don't resemble each other in size, shape, or color, I worked each chapter toward its individual purpose and trusted the total picture would emerge as an attractive and informative whole.

Naturally, there were bound to be contrasts and contradictions when 12 separate individuals are involved (ask any judge or lawyer!), but this adds further interest and forces the reader to take sides, form opinions, and set his own mind straight as to where he stands in the visual perspective of humorous illustration.

Repetition, too, is bound to occur, despite the variety of approaches. For the most part, repetitive ideas were deleted to avoid boredom. But in some cases, repetition drove home a point that warranted special attention and was left as was. Such a point was the importance of individuality and of finding one's own style and approach through work and sincerity, rather than through imitation. Though the initial stages of development appear more difficult for those who strive for originality than for those who take the easier routes, the end result is *personal*, which makes improvement more rapid and performance easier later on because it's *natural* and not ap-

plied. Each artist has only *himself* to give—it makes no sense to give *someone else*. Imitation, in fact, can actually prove harmful, for though certain problems appear to be solved by "borrowing" the solutions of others, the artist who hasn't learned to solve these problems his own way becomes dependent upon his *sources* to continuously come up with the solutions. At best, an imitator becomes a shadow cast by the original. And his work will be accorded the respect usually directed toward the carbon copy.

Finally, there are no absolutes in humor. No one can create a formula that will guarantee a successful idea or gag every time. You never know beforehand if something is going to look funny or read funny . . . although it strikes *you* funny, will others react in the same way? Everyone has different tastes and reactions to humor, and everyone thinks *he* has a "good sense of humor." For that reason, the best idea you ever come up with may never see print, while the one chosen by some editor which you feel to be one of your weakest, pulls in a record amount of approving mail. You just never know. The only thing a humorist can do is keep working and hope that there will always be enough positive reaction to his efforts to keep him at the drawing board rather than sweeping floors underneath the drawing boards of others. If the work is original and sincere, half the battle is already won.

Index